Jim Zuckerman's Secrets to Great Photographs

PerFect exPosuRe

JIM ZUCKERMAN'S SECRETS TO GREAT PHOTOGRAPHS

PerFect exPosuRe

JIM ZUCKERMAN

WRITER'S DIGEST BOOKS

Cincinnati, Ohio
www.writersdigest.com

Perfect Exposure. © 2003 by Jim Zuckerman. Manufactured in Singapore. All rights reserved. No part of this book may be reproduced in any form or by any electronic or mechanical means including information storage and retrieval systems without permission in writing from the publisher, except by a reviewer, who may quote brief passages in a review. Published by Writer's Digest Books, an imprint of F&W Publications, Inc., 4700 East Galbraith Road, Cincinnati, Ohio 45236. First edition.

Other fine Writer's Digest photography books are available from your local bookstore or direct from the publisher at <www.writersdigest.com> or by calling (800) 448-0915.

07 06 05 5 4 3 2

Cataloging-in-Publication data is available from the Library of Congress at <http://catalog.loc.gov>.

Edited by Brad Crawford
Cover and interior design by Andrea Short
Interior layout by Kathy Bergstrom

DEDICATION

To my niece Sara and her husband, Hyim.
May your life together be joyous and deeply fulfilling.

ACKNOWLEDGMENTS

Thanks to my editor, Brad Crawford, whose diligence, sharp eye and collegial spirit helped make a better book. And thank you to designer Andrea Short for taking good care of my photographs.

ABOUT THE AUTHOR

Jim Zuckerman left his medical studies in 1970 to turn his love of photography into a career. He has lectured and taught creative photography at many universities and private schools, including UCLA, Kent State University, the Hallmark Institute of Photography and the Palm Beach Photographic Center. He also has led international photo tours to destinations such as Burma, Thailand, China, Brazil, Eastern Europe, Greece, Kenya, Morocco, Alaska and Papua New Guinea.

Zuckerman specializes in wildlife and nature photography, travel photography, photo and electron microscopy, and digital special effects. He is a contributing editor to *Petersen's Photographic*. His images, articles and photo features have been published in scores of books and magazines including several Time-Life Books, National Geographic Society publications, *Outdoor Photographer, Outdoor and Travel Photography, Omni Magazine, Condé Nast Traveler, Science Fiction Age,* Australia's *Photo World* and Greece's *Opticon.*

Zuckerman is the author of eight photography books: *Visual Impact; The Professional Photographer's Guide to Shooting & Selling Nature & Wildlife Photos; Outstanding Special Effects Photography on a Limited Budget; Techniques of Natural Light Photography; Jim Zuckerman's Secrets of Color in Photography; Fantasy Nudes; Capturing Drama in Nature Photography;* and *Digital Effects.*

His work has been used for packaging, advertising and editorial layouts in thirty countries. Jim's images have also appeared in calendars, posters, greeting cards and corporate publications. His stock photography is represented by Corbis Images.

table of contents

[intro]

Virtually all photographers feel insecure with exposure, and with good reason. There are just too many things that can go wrong. All too often, we get our film back from the lab with high hopes of great pictures, but quickly our enthusiasm turns to frustration and disappointment when we discover they are too light or hopelessly dark.

I know that photographers don't really want to deal with exposure problems. We would like exposure meters to perform flawlessly so each and every picture is perfect. We don't want to think about all the things that can go wrong, and we don't want to be burdened with the time and mental energy it takes to find solutions. I'm sorry. It just doesn't work that way. Exposing your pictures correctly does require your knowledge and energy.

The technological advances of computer-programmed automatic exposure systems promised to be our photographic salvation, but you know very well that we aren't that lucky. Automatic meters built into cameras today are indeed very sophisticated, and they are accurate in many situations. The operative word, however, is many. The obvious implication is that there are many other situations in which they are not accurate at all. I know you can attest to this: Consider for a moment how many slides or negatives you've thrown away due to poor exposure.

You could probably fill an entire room in your home.

How, then, can you rely on automatic metering? The bigger question is, Why spend thousands of dollars on equipment, film and travel if you don't get properly exposed pictures?

Automatic metering systems are seductive. You depend on them. You assume most or all of your shots will be accurately exposed, and if you're unsure in a few situations, you can cover all your bases with bracketing. (Bracketing refers to shooting several frames, usually three, for each composition: One frame uses the meter's reading, and the other two are over- and under-exposed.) I call this the shotgun approach to photography. If you take enough pictures, you're bound to get a few good ones.

I do photography the old-fashioned way. I think about it. This book is designed to teach you to think about it too. I want you to understand why meters fail and how to get perfect exposures despite that failure. I hope you'll appreciate how you can use handheld light meters in addition to your camera's meter and also to learn how to read outdoor light with no meter at all.

By the time you finish reading this book, your exposures should be more consistent and more predictable. Just in the money you save by not throwing away so many frames, this book will pay for itself many times over.

why meters fail

why meters [fail]

too frequently, the built-in light meter in your camera fails to produce properly exposed pictures. This is not your fault, nor is it the fault of the engineers who designed the camera. It happens because meters are intended for everyday situations: a family gathering in the backyard, for example. With the sun behind you, illuminating the subjects with front lighting, the tones in the picture are not too light or too dark. They are *middle toned*. All light meters will read this scene with accuracy.

When photographic circumstances are more extreme, however, such as shooting winter landscapes or trying to capture a silhouette against the sun, light meters are not reliable. They try to interpret your extreme composition as one that is middle toned. Usually, the result is a disaster. The photos turn out over- or underexposed, where either the highlights are washed out or the shadows go black with no detail. Why does this happen?

Consider shooting a snow-covered tree in a snowstorm. Everything is white. The meter in your camera is programmed to provide readings with the assumption that the subject is middle toned. (The terms *middle toned*, *medium gray* and *18 percent gray* are used interchangeably. They all refer to tones of any color that are approximately midway between black and white.) When the subject is all white, as in this example, the meter tries to make it middle gray. That's why your meter fails. It tries to make everything gray by underexposing the picture.

When you are photographing a dark subject, the same problem occurs but with the opposite result. A black-feathered bird photographed against a black background will end up being overexposed because the meter again tries to render the composition medium gray. When a black subject is overexposed, it becomes gray. The problem, of course, is that it should look black.

Study the following examples to learn when you can rely on your meter and when you can't. This should give you a feel for the types of situations where in-camera meters fail. Subsequent chapters explain how to deal with this problem.

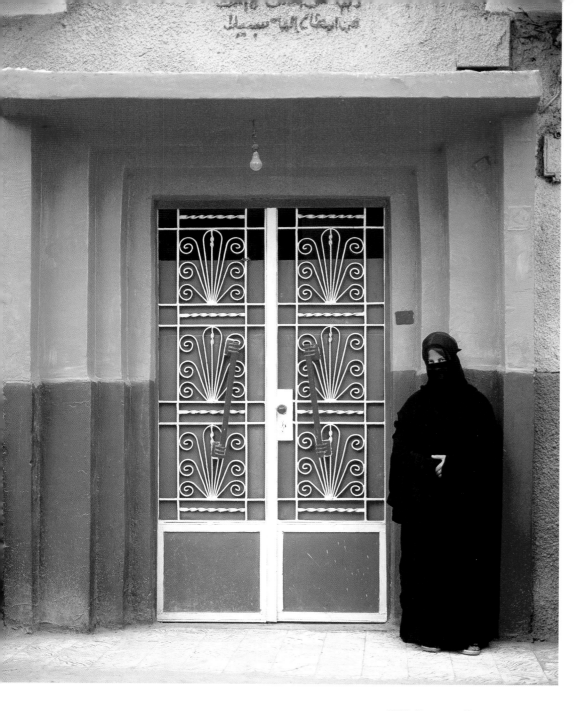

With the exception of the veiled woman, this shot in Egypt consists of middle tones. Any in-camera meter will have no problem providing a perfect exposure. The woman's black attire isn't a large enough element in the composition to cause a problem by fooling the meter into a false reading.

tech data: Mamiya RZ 67 II, 250mm telephoto lens, 1/60, f/4.5, Fujichrome Velvia, tripod.

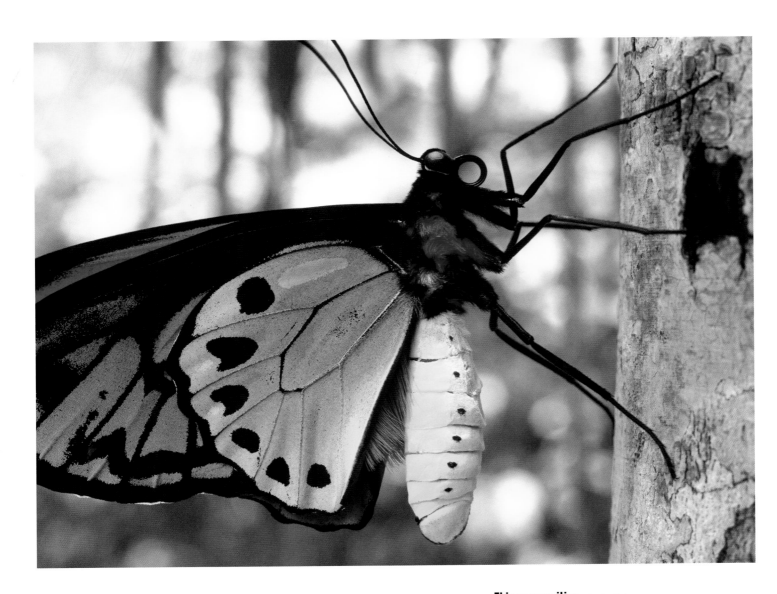

This composition of a birdwing butterfly from New Guinea is also comprised of tonal values that any built-in camera meter can read without difficulty. Yes, there is some skylight coming through the out-of-focus background above the insect, but it isn't enough to adversely affect the reading.

tech data: Mamiya RZ 67 II, 250mm telephoto, Canon 500D diopter, 1/30, f/8, Fujichrome Provia 100F, tripod.

Virtually the entire frame in this shot of Zabriskie Point in Death Valley is middle toned. This is the kind of tonality that in-camera meters are programmed to read with consistent accuracy. If your meter fails to provide a good exposure for this picture, it needs to be serviced and recalibrated.

tech data: Mamiya RZ 67 II, 250mm telephoto, 1/15, f/16, Fujichrome Velvia, tripod.

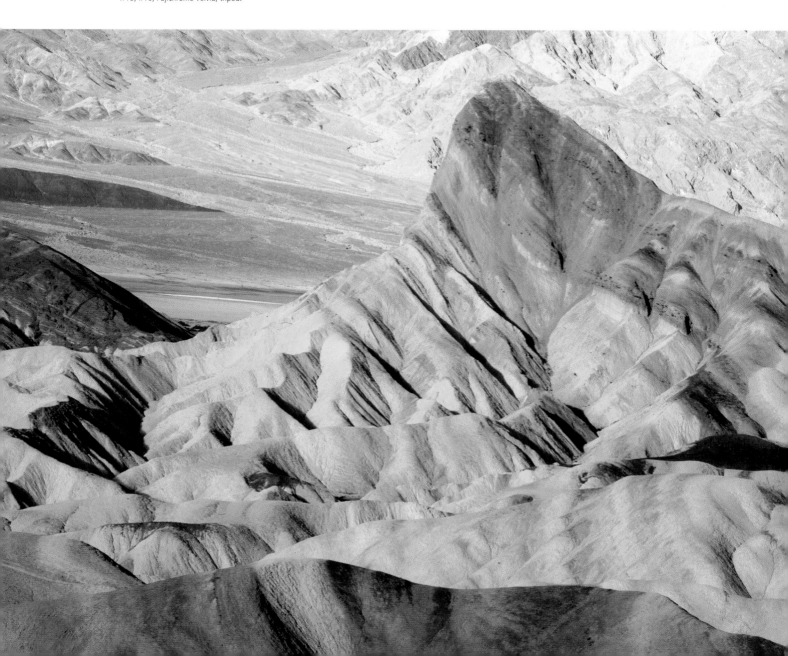

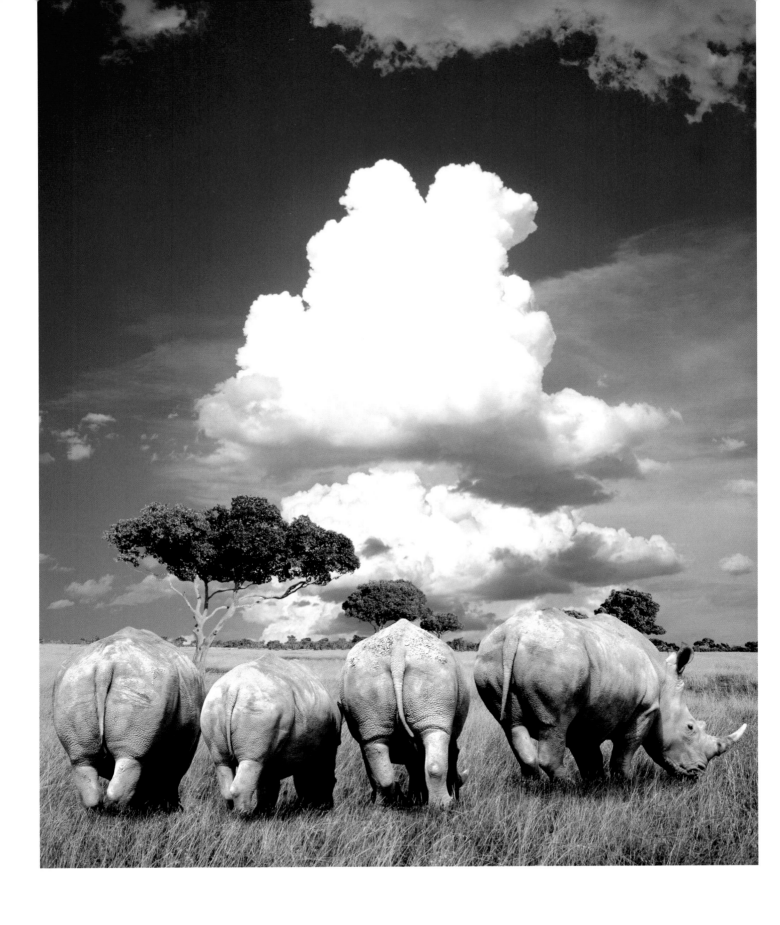

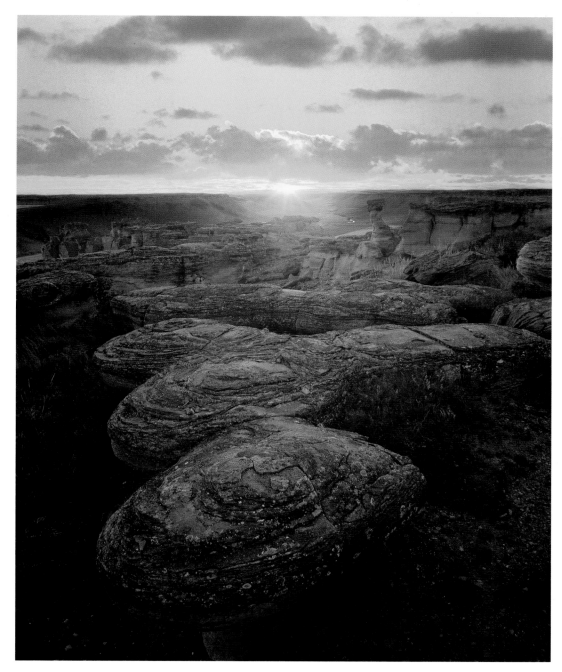

Any time you include the sun in the composition, the brilliant light can deceive an in-camera meter into underexposure. In this instance, the sun is diminished because it's low in the sky and partially obscured by the horizon. The meter might be accurate, but it also might underexpose slightly. It's hard to know. The techniques I explain in subsequent chapters take the guesswork out of exposure. This picture was taken at Jerusalem Rocks in Montana.

tech data: Mamiya 7, 43mm wide-angle lens, 1/4, f/22, Fujichrome Velvia, tripod.

[opposite page]

This shot might be problematic. The large white cloud dominates the center of the frame, and this is the region where in-camera meters take a large percentage of their information. The whiteness might cause underexposure because the meter is trying make medium gray out of a brighter than normal scene. This is one of those instances where it's hard to determine whether the meter will be accurate. Most photographers bracket their exposures to cover their bases in a situation like this. I don't.

tech data: Mamiya RZ 67 II, 50mm telephoto, 1/125, f/11–f/16, Fujichrome Provia 100F, camera rested on beanbag in Land Rover.

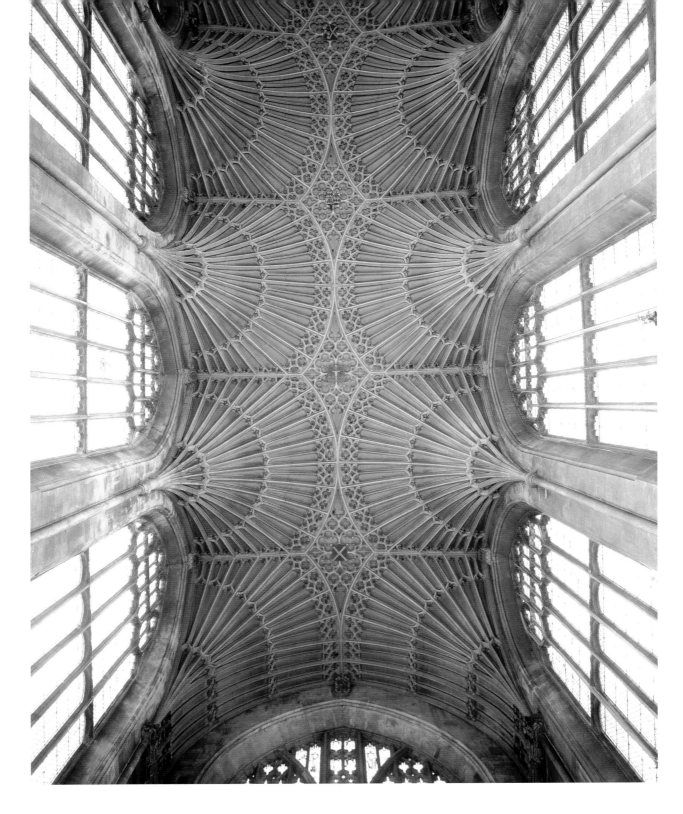

The ceiling of Bath Cathedral in England is middle toned, but the brilliant skylight filtering into the interior through the huge windows may very well influence the meter reading. If you include only the ceiling detail in the reading (by using the spot mode—see page 29 in chapter two), the camera's light meter will be accurate. However, if you include the window light in the reading, the shot will definitely be somewhat underexposed.

tech data: Mamiya RZ 67 II, 50mm wide-angle lens, 1/4, f/22, Fujichrome Velvia, tripod.

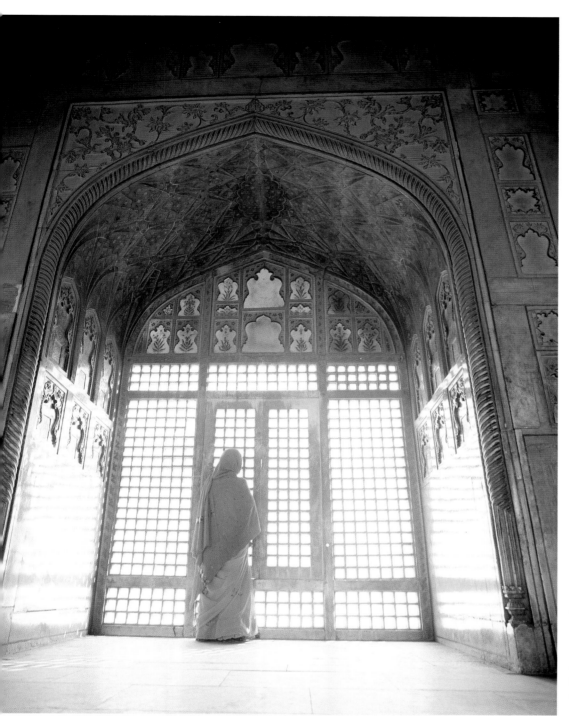

Whenever you photograph a person in front of a bright window, as I did here in Agra Fort in India, the natural light is several f/stops brighter than the subject and typically fools the meter into underexposure. Actually, the camera is properly exposing for the ambient daylight, but in the process the person usually appears too dark. I had to expose for the model and disregard the bright background. See chapter five for more on backlighting.

tech data: Mamiya RZ 67 II, 50mm wide-angle lens, 1/30, f/5.6, Fujichrome Velvia, tripod.

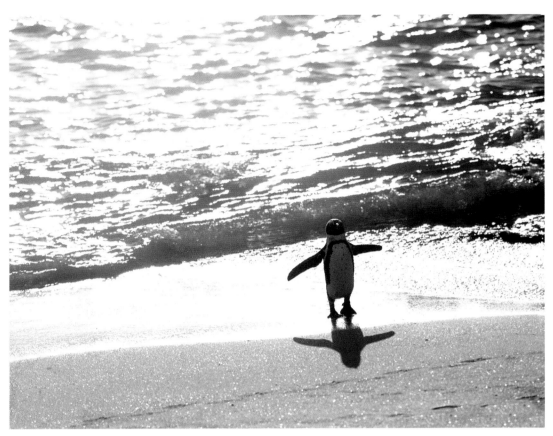

Similar in concept to the photo on page 21, this jackass penguin in South Africa was partially silhouetted against the sun's reflection on the ocean. If a camera's automatic meter read the light in this shot, it would have turned out much darker than you see here, and the bird would have been a silhouette. Instead, I compromised between retaining detail in the penguin and texture in the water.

tech data: Mamiya RZ 67 II, 500mm APO telephoto lens, 1/250, f/11–f/16, Fujichrome Provia 100 III, tripod.

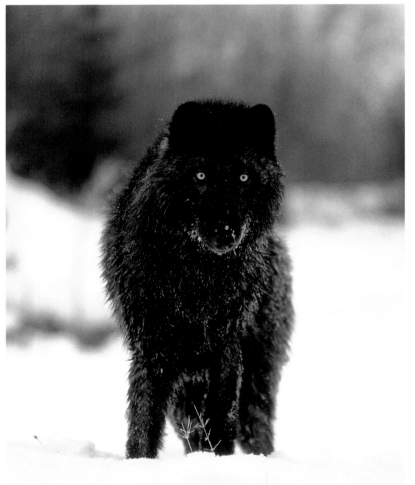

A black wolf on snow is perhaps the ultimate in insecure exposure situations. I would never rely on a built-in camera meter to give me an accurate reading under these circumstances. You can reason that the dark animal and snowy environment will average out so the meter will give an acceptable reading, but this assumption is just as likely to be wrong. I like to know my exposures are perfect. In chapter four you will learn how to get perfect exposures every time in this type of situation. I took this shot under very dark conditions.

tech data: Mamiya RZ 67 II, 350mm telephoto lens, 1/60, f/5.6, Fujichrome Provia 100F pushed one stop to 200 ISO, tripod.

This is another impossible situation for an in-camera meter: backlighting on snow. I was shooting right into the sun. When the meter tries to make this scene middle gray, it becomes hopelessly underexposed. Notice how the sun in this picture is very different in intensity from the sun setting above the Jerusalem Rocks on page 19. The sun was partially obscured by the horizon in the Montana shot, and its diminished strength had less impact on the meter than it did in this picture, taken in Yellowstone. In either case, however, I would not rely on the in-camera meter reading. I just couldn't be sure of its accuracy.

tech data: Mamiya RZ 67, 50mm wide-angle lens, 1/125, f/16, Fujichrome Provia 100, tripod.

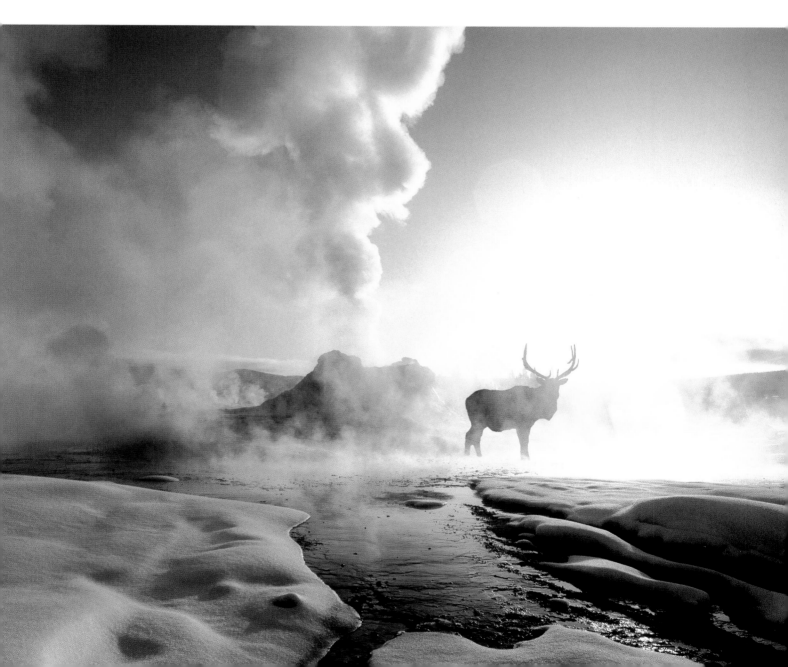

This is the classic white-on-white winter photograph. There are no middle tones from which an in-camera meter can read the light. Instead, the meter is programmed to interpret this scene as gray and subsequently underexposes the picture. As difficult as you might think it is to obtain an accurate light reading here, it's really very easy. In chapter four I take all the mystery out of exposing on snow.

tech data: Mamiya RZ 67 II, 500mm APO telephoto lens, 1/125, f/6, Fujichrome Provia 100, tripod.

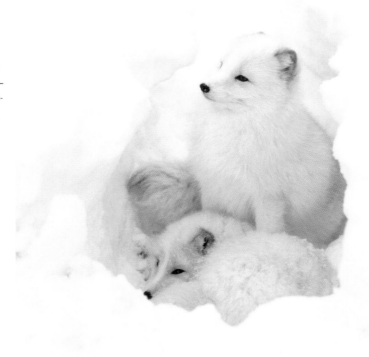

The black feathers of this turkey against dark shadows present the opposite problem of the previous picture. Automatic metering modes try to interpret the black-on-black composition as medium gray, hence overexposing it.

tech data: Mamiya RZ 67 II, 350mm APO telephoto, 1/60, f/5.6, Fujichrome Provia 100F pushed one f/stop to 200 ISO, tripod.

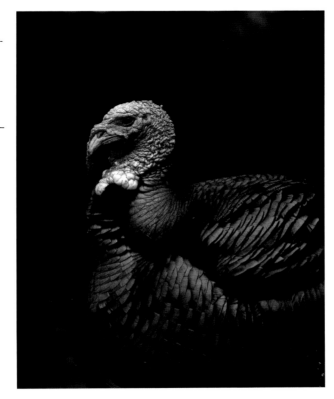

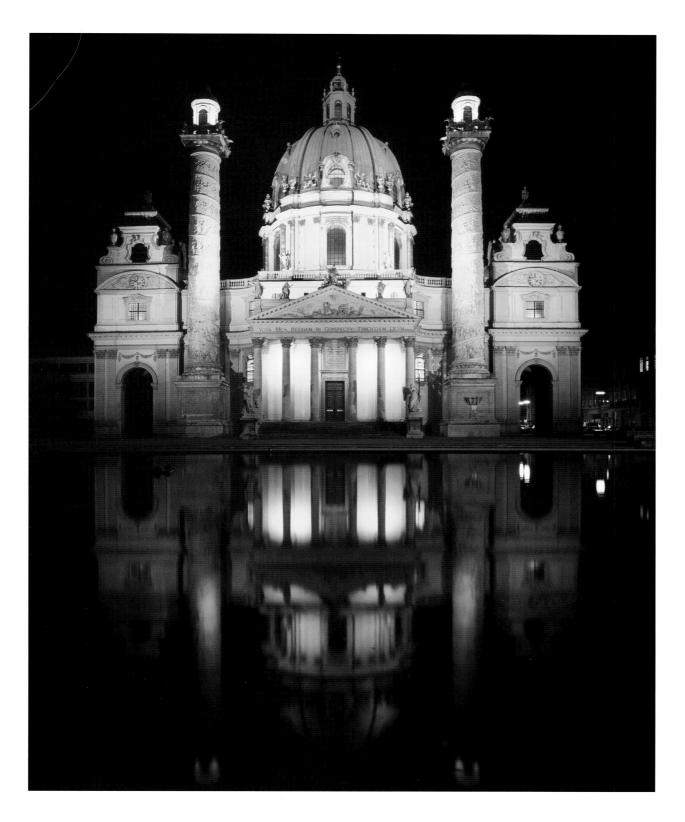

Exposing at night is difficult because the extreme contrast between the blackness of night with illuminated portions of the frame confuses a meter. It tries to average the values of light and dark, and more often than not, the computed result is not what you want. In situa-tions where an illuminated building fills the frame, you can probably rely on the built-in meter to give you an accurate light reading. However, if much of the frame were black, I would not trust the programmed response of your camera's meter. This shot, taken in Vienna, is bor-derline. When in doubt, I don't rely on any in-camera meter.

tech data: Mamiya RZ 67, 110mm normal lens, 10 seconds, f/5.6, Fujichrome Velvia, tripod.

chapter two
modes of metering

modes of [metering]

*i*f you use a single lens reflex (SLR) camera, the built-in meter is referred to as TTL—through the lens. (All metering modes built into cameras read light reflected from the subject.) This means the meter sees only the light striking the film. Notwithstanding the various ways a meter can be fooled, a TTL meter is a very accurate method of automatic metering.

There are several methods camera manufacturers have devised in their attempts at giving us accurate exposures. It's important to understand what these are, so when you are buying a new camera you'll understand which features you want.

Manual metering: If you use a manual camera, or if you take an automatic metering camera off automatic and switch to the manual mode, you must manually set both lens aperture and shutter speed without the help of a built-in meter giving you exposure data. You can use your own experience to judge the exposure or use a handheld light meter to provide the exposure information. (See pages 132 and 140 for discussion of the sunny f/16 rule, which will help you calculate the proper exposure for manual metering.)

Aperture priority: In this mode, you set the lens aperture, and the camera automatically sets the shutter speed. When I shoot 35mm, I rarely use this feature. It is applicable when shooting landscapes and architecture, where the subject is motionless and you want maximum depth of field (and the shutter speed, no matter how long, is irrelevant), or when the light level is low and you need to shoot wide open to take advantage of the fastest shutter speed possible.

Shutter priority: I use this mode much more than aperture priority. You select the shutter speed, and the meter varies the lens aperture according to the light. I believe the choice for shutter speed is always more important than the lens aperture because depth of field is irrelevant if the picture is not sharp. In other words, if you use aperture priority and choose f/16 for expansive depth of field but the shutter speed is slow, say 1/8, due to low light levels, any moving

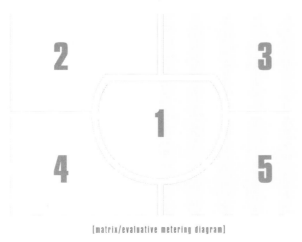

[matrix/evaluative metering diagram]

subject will be blurred. Your shot will have impressive depth of field, but so what? Your goal should be to get a sharp image, and this one would be hopelessly blurred. This is why I maintain that shutter speed is the most important decision regarding exposure.

Spot metering: The camera automatically takes a meter reading from a small area in the center of your composition. The thinking here is that the center of the frame is the most important and that if it is exposed correctly, you'll be a happy camper.

Matrix and evaluative metering: These are two names given to the same metering technique by Nikon and Canon, respectively. The automatic meter takes multiple readings from the entire frame and analyzes them collectively. This is supposed to be the most accurate metering method of all. However, it too can fail given the wrong circumstances.

The diagram at bottom left on page 28 shows how cells are divided and light measured in five-segment matrix/evaluative metering. Sensors on the left side read regions 2, 4 and the left half of 1. Sensors on the right read 3, 5, and the right half of 1. A *centerweighted* reading counts all of region 1 in both measurements.

Off-the-film-plane metering: This metering method reads the light bouncing off the surface of the film in the camera. All of the other methods read the light directly through the lens *before* it hits the film. If you use fill flash, a combination of ambient light and flash, off-the-film-plane metering will correctly balance the two light sources.

Handheld meter (incident): An incident meter reads the light falling onto the scene from either the sky or an artificial light source (above right). This meter is separate from the camera and has a hemispherical white dome that covers the light-sensitive electronics. To use it, point that dome toward the camera lens. The meter must be held in the same light as the subject. It is extremely accurate in most, but not all, situations.

[handheld reflected meter]

[handheld incident meter]

Handheld meter (reflected): Also separate from the camera, this meter allows you to read the light reflecting from the subject, just like TTL meters. Unlike TTL meters, handheld reflected meters can pinpoint the precise exposure for a small area, as with one-degree spot mode. This meter doesn't have to be in the same light as the subject.

This book is designed to help you know when the various methods of metering work and when they fail. Study the following pictures as I explain how I metered each situation. Because there isn't necessarily one correct way to read a scene, you will see both the method I used and some alternatives.

I used a handheld incident meter to read the soft light for this portrait in the Peruvian highlands. The Sekonic L-508 meter has both incident and reflected capabilities, which eliminate the need to carry two handheld meters. (There is also now an L-608 model available.) Here, I used it on incident mode. However, because the light is uniform on the subjects and most of the tones in the frame are middle gray, a TTL meter on any of the automatic modes would be fine.

tech data: Mamiya RZ 67, 250mm telephoto lens, 1/60, f/4.5, Fujichrome 50, tripod.

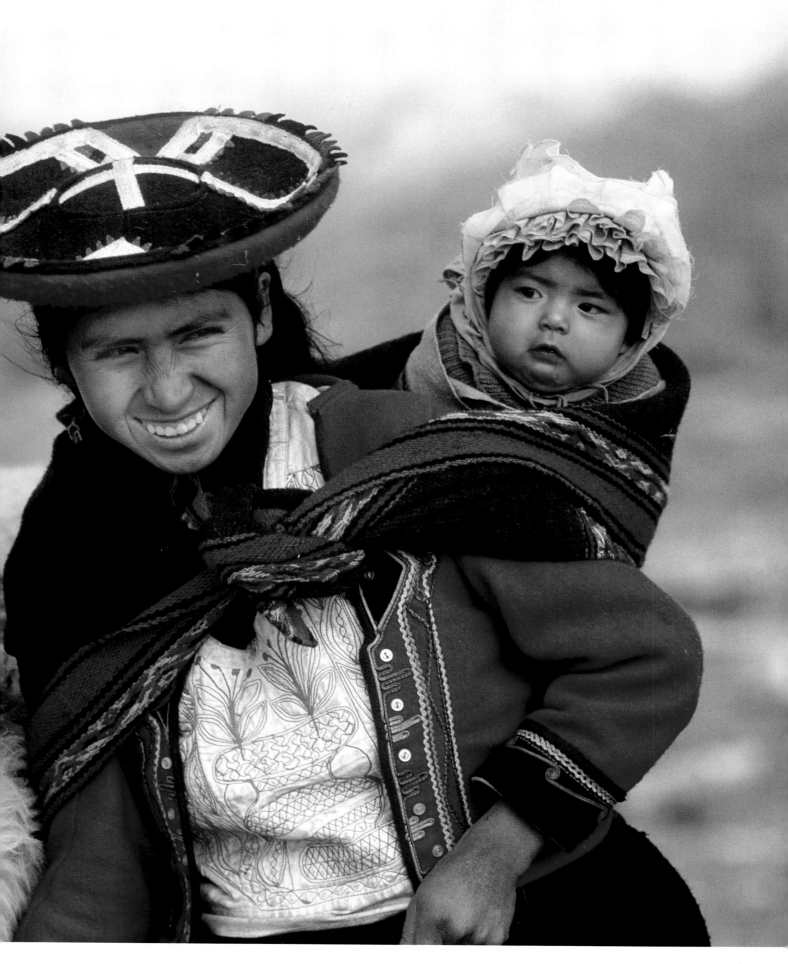

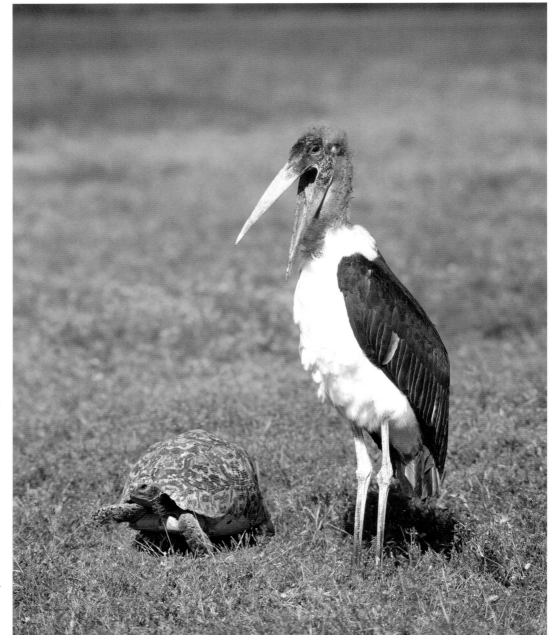

I normally avoid midday lighting when shooting wildlife, but this interaction between a stork and a tortoise in Kenya was irresistible. Any TTL automatic exposure mode would give a correct exposure here, from matrix metering to shutter or aperture priority. Even the program mode would be accurate. Because I habitually use a handheld meter for ultimate control, I used my Sekonic L-508 on incident mode.

tech data: Mamiya RZ 67 II, 350mm APO telephoto lens, 1/250, f/6, Fujichrome Provia 100, camera rested on beanbag in Land Rover.

[opposite page]

This portrait of a Thai dancer presents a more challenging situation. The backlighting from a bright sky is so much lighter than the skin tones that I suspect it would unduly influence most automatic metering. Three ways to take an accurate reading here:

1. With your TTL meter in spot mode, take a reading that includes only skin on the subject's face. Switch to manual mode, use the spot reading, compose the picture, and shoot.

2. Use a handheld reflected meter on a narrow angle, and read the skin tone.

3. Use a handheld incident meter, point the hemispherical white dome toward the camera lens, and take a reading. I shot this picture with a 35mm camera, so I used the first option.

tech data: Canon EOS 1, 50–200mm zoom lens, Ektachrome 64, handheld. Exposure information unrecorded.

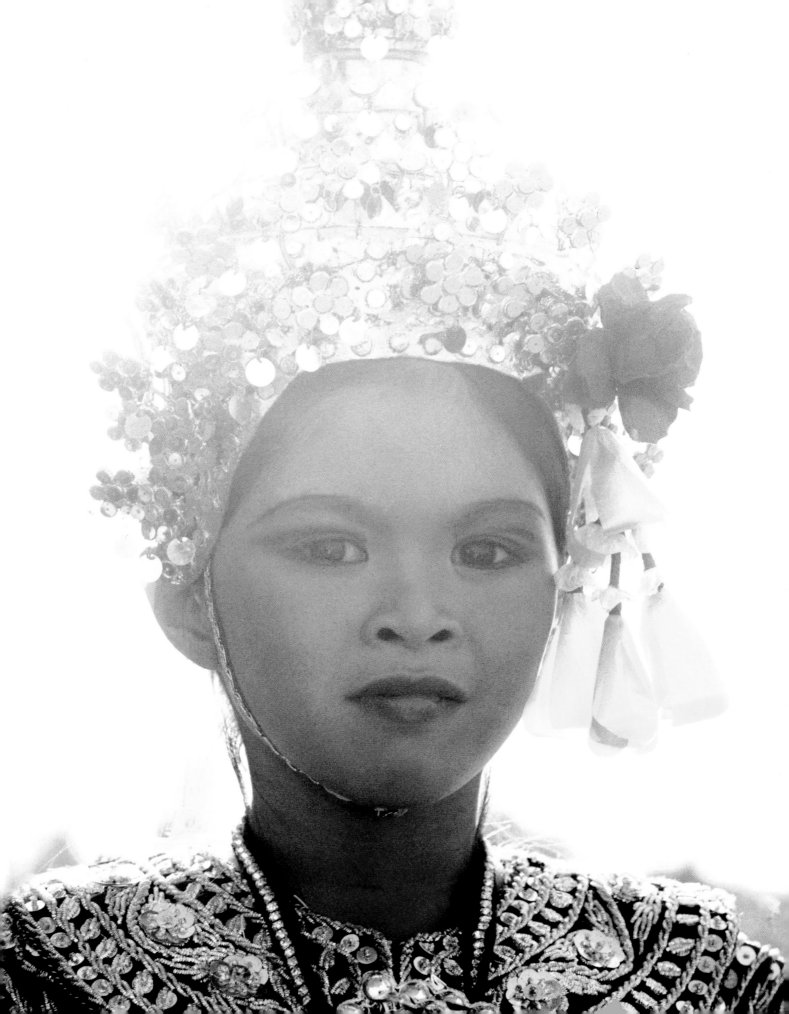

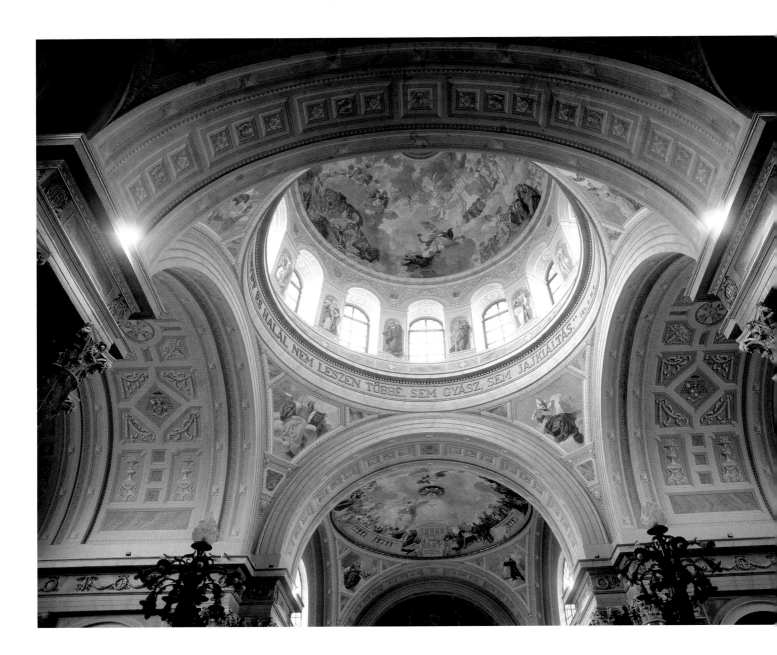

Cathedral ceilings, like this one in Eger, Hungary, are often difficult to read because high windows let bright daylight filter into dark interiors, and the contrast can thwart meter readings. It's best to use either the spot meter mode in your camera or a handheld reflected meter. If you use the TTL spot mode, put a telephoto lens on the body and take the reading. The narrow angle of coverage will allow you to pinpoint a specific area of the frame for an accurate metering reading. Then, switching to manual mode and setting the aperture/shutter speed correctly, use another lens, such as a wide-angle, for the shot.

I used my handheld meter on reflected mode. I took a reading on the mustard-yellow color in the dome as my middle-gray tone. If you take a reading on a middle tone in the composition, all other tonalities will fall into place.

tech data: Mamiya RZ 67 II, 50mm wide-angle lens, 1/4, f/5.6, Fujichrome Velvia, tripod.

Sunset lighting in Jedediah Smith Redwoods State Park, California, presented an interesting exposure challenge. A handheld incident meter cannot read backlighting. I don't trust any of the automatic exposure modes to read such subtle tonalities and contrasts as in the glowing leaves and flare around the massive trunks, especially with the shadows and white sun. Matrix metering might do a good job with this exposure, or it might not. I'm not a fan of taking a shot and then bracketing all over the place to make sure I've got at least one frame. I prefer to do it right the first time.

I used my Sekonic L-508 in the reflected mode, and with the one-degree spot meter I read a middle-toned portion of the large gray trunk about half way up (at the left side of the picture). This reading gave me the correct exposure.

tech data: Mamiya 7, 43mm wide-angle lens, 1/4, f/22, Fujichrome Velvia, tripod.

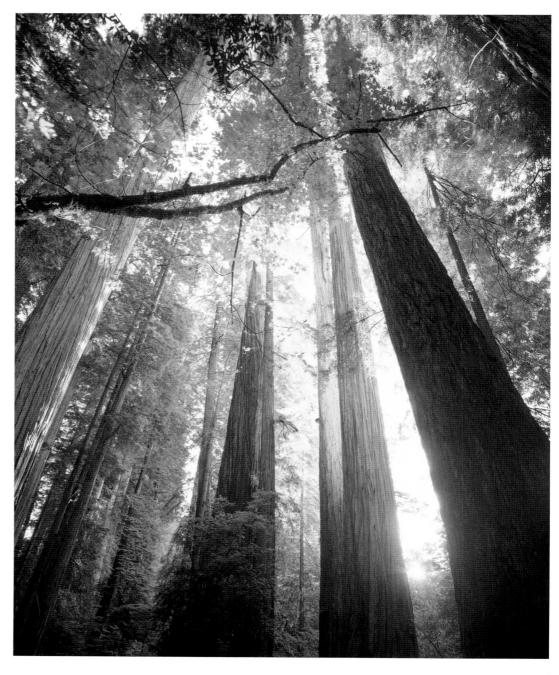

Even though these Siberian tigers are on snow, the white portion of the frame is not dominating. Most of the composition, consisting of the forest and the cats themselves, is middle toned. Therefore, matrix or evaluative metering would work well here. Alternatively, you could take a reading from the fur with the TTL meter on the spot mode.

Since this early morning was overcast and the soft light wasn't changing, I simply took a single reading with the handheld incident meter and used that information for the entire shoot.

tech data: Mamiya RZ 67 II, 350mm APO telephoto, 1/60, f/5.6, Fujichrome Provia 100F pushed one f/stop to 200 ISO, tripod.

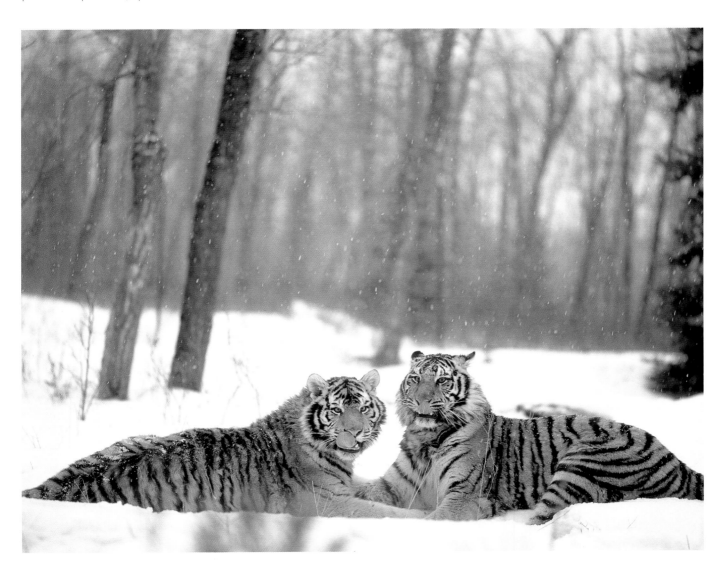

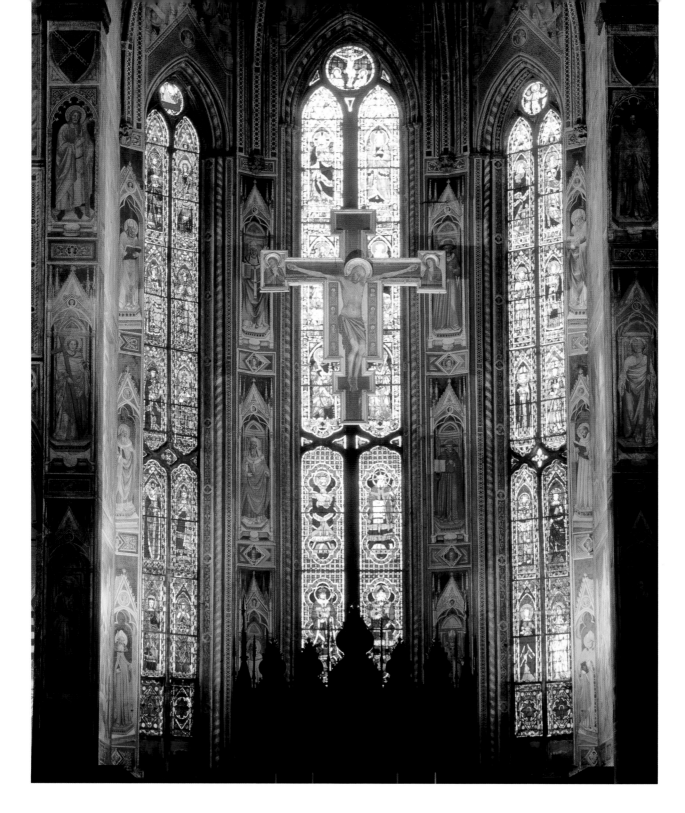

Balancing the exposure of stained glass against the interior of a church is tricky, but it helps if artificial light brightens the art and architecture inside. A matrix or evaluative reading of this composition might work, but contrasty shots like this can fool the best of meters. If the result is a bit too light, the details in the windows will be blown out. If the picture is underexposed even a little, you will lose the detail in the shadows.

The safest method is to find a middle tone and take a spot reading on it. I again used the Sekonic L-508 on reflected mode, but any 35mm shooter could use the spot mode with a telephoto lens to read a tiny portion of one of the paintings.

tech data: Mamiya RZ 67 II, 250mm telephoto lens, 1 second, f/32, Fujichrome Velvia, tripod.

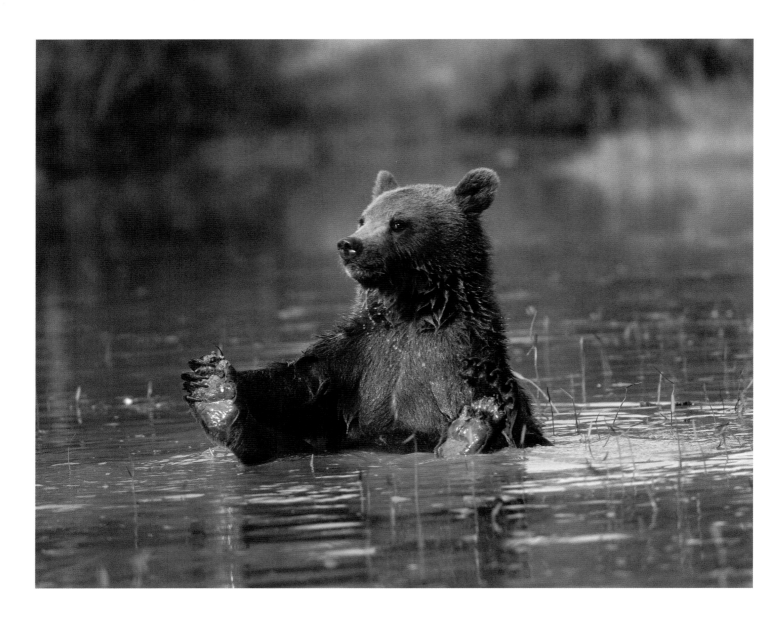

With some images, the slightest over- or underexposure is critical. If this young grizzly were a bit darker, the detail in his brown fur would disappear. That's why I hesitate to trust automatic metering modes—it's difficult to predict precisely how they will interpret a subject. Bracketing can solve the problem, but sometimes there isn't time to bracket.

I read the light for this shot with a handheld incident meter, the L-508. Could I have used the reflected mode to read the brown fur, using it as a gray card? Perhaps, but for this metering strategy to work, the brown color must be very close in tonality to a gray card, or 18 percent reflectivity. If not, the exposure will be wrong. With the bear in constant motion as he played in the water, I didn't want to take the chance of making an error.

tech data: Mamiya RZ 67 II, 500mm APO tele-photo, 1/125, f/6, Fujichrome Provia 100F, tripod.

When you use automatic metering and bracket exposures, in essence you're saying that the sophisticated TTL meter in your expensive camera isn't reliable. This is an insecure way to photograph. Once you understand exposure, you banish the insecurity and will expose your images perfectly virtually all of the time.

The sunset lighting on snow-covered mountains just outside Zion National Park, Utah, was truly spectacular, but it didn't last long. I realized that I couldn't use an incident meter because the light on the mountains was not the same as the light where I was standing. Instead, I used a handheld reflective meter on one-degree spot mode to read a middle-toned portion of the cliff face. I used the rocks in shadow, just above the orange glow, on the left side of the picture.

With a 35mm camera, I could have taken a spot reading and then used the exposure lock button to prevent the exposure from changing as I composed the final picture.

tech data: Mamiya RZ 67 II, 250mm telephoto lens, 1/8, f/4.5, Fujichrome Velvia, tripod.

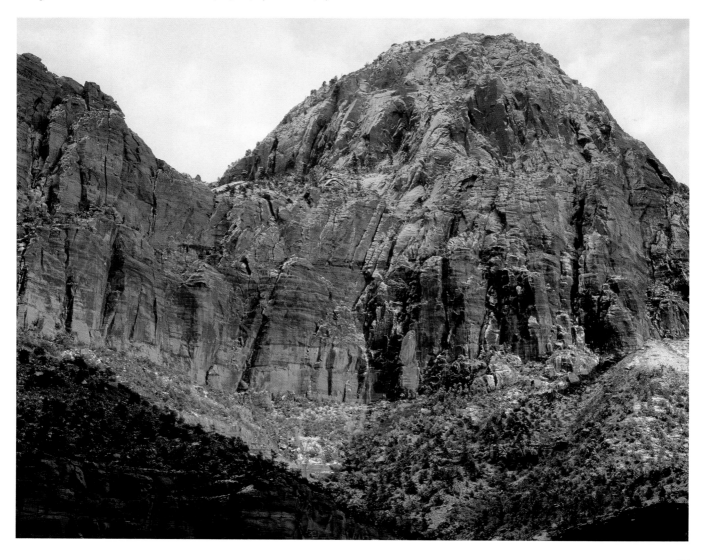

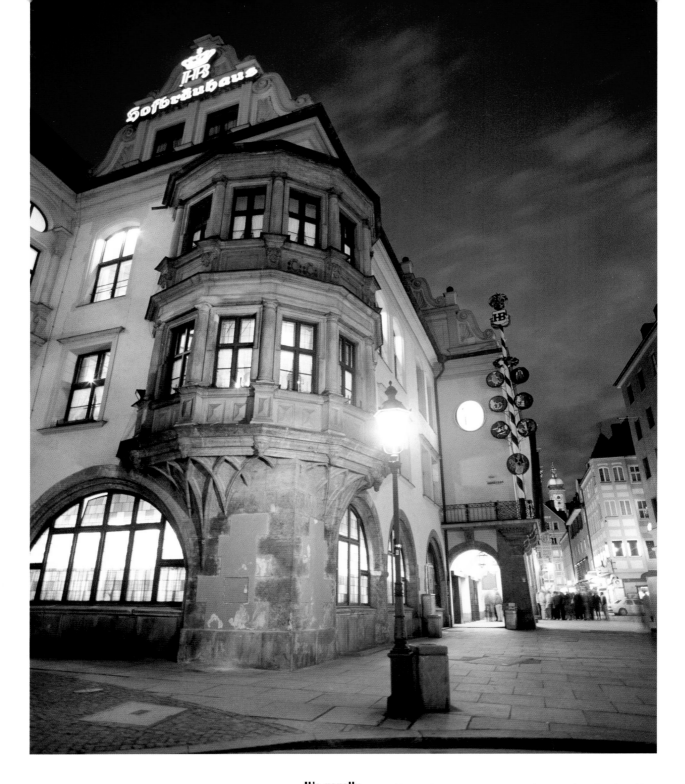

It's usually impossible to take an accurate light reading at night. This is true for any kind of meter. But when I took this picture in Munich, Germany, I recognized that most of the frame was essentially middle toned (unlike the photo on page 25). Virtually any metering mode could read the stonework on the famous Hofbrauhaus: matrix/evaluative, shutter priority, program, aperture priority and so on. Though I shot this with a medium format Mamiya RZ 67, as an experiment, I metered it with my Canon EOS 1 on program mode.

tech data: Mamiya RZ 67, 50mm wide-angle lens, 64 seconds, f/32, Fujichrome Velvia, tripod. (The Canon meter gave me a reading of 1 second at f/4. When I closed down for depth of field, the exposure time became 64 seconds.)

I metered this portrait of a Ndebele woman from South Africa with both the incident and reflected modes. The shaded wall was dark, and I wanted to make sure I would have enough exposure on her face while not blowing out the colorful design of her home. For the reflected reading, I used the spot mode and read the blue paint in the design in the lower-middle portion of the wall. When I metered using the incident mode, I placed the meter next to the woman's face and pointed the white dome of the hand held meter toward the camera lens. I placed the meter next to the woman's face because an overhand kept it in shadow. As the meter moved away from the wall, the light changed.

The reflected and incident readings were identical.

tech data: Mamiya 7, 43mm wide-angle lens, 1/60, f/4.5, Fujichrome Provia 100F, tripod.

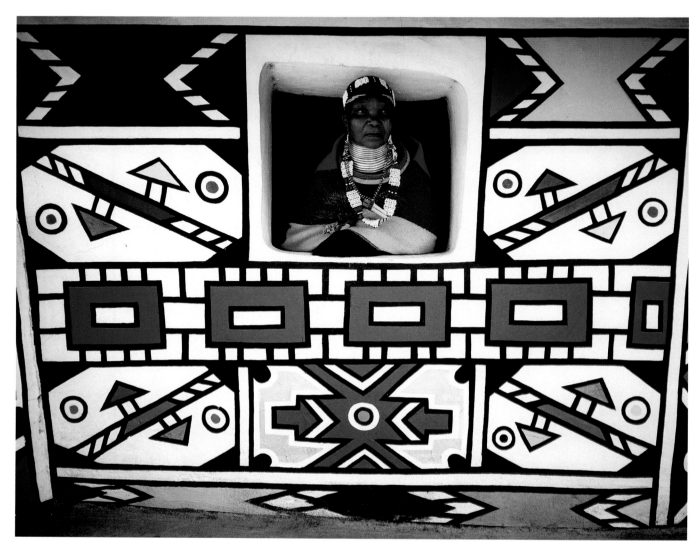

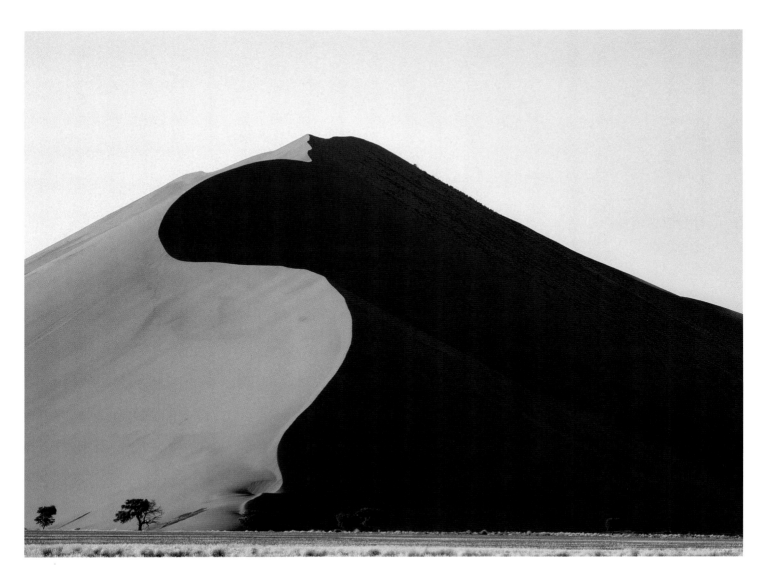

To compare results, I photographed this classically beautiful sand dune at Sossosvlei, Namibia, using two different metering methods. For the first exposure, above, I used the Sekonic L-508 on incident mode. The incident reading measured the light falling on the scene and provided an accurate rendition of what I saw with my eyes. The shadows are dark but hold detail. The rich color of the highlighted sand is correctly exposed.

I metered the photo at right with the TTL meter in an RZ pentaprism. This reflected light reading averaged the various tones in the composition and gave me a slightly different exposure from the incident meter. The shadows are lighter and show more detail, but the portion of the dune receiving the early morning light is not as saturated. The difference between the exposures was 1/2 f/stop.

Note that the incident meter reading depends on its position relative to the light source. If I had angled it slightly toward the sun, the exposure would have been darker. If it were rotated away from the sunlight a few degrees, the result would be very much like the reflected reading. As you gain more experience, you can tweak your readings by choosing to emphasize either the highlights or the shadows.

tech data: Both photos: Mamiya RZ 67 II, 350mm APO telephoto, Fujichrome Velvia, tripod. Above: 1/8, f/32; right: 1/8, f/22–f/32.

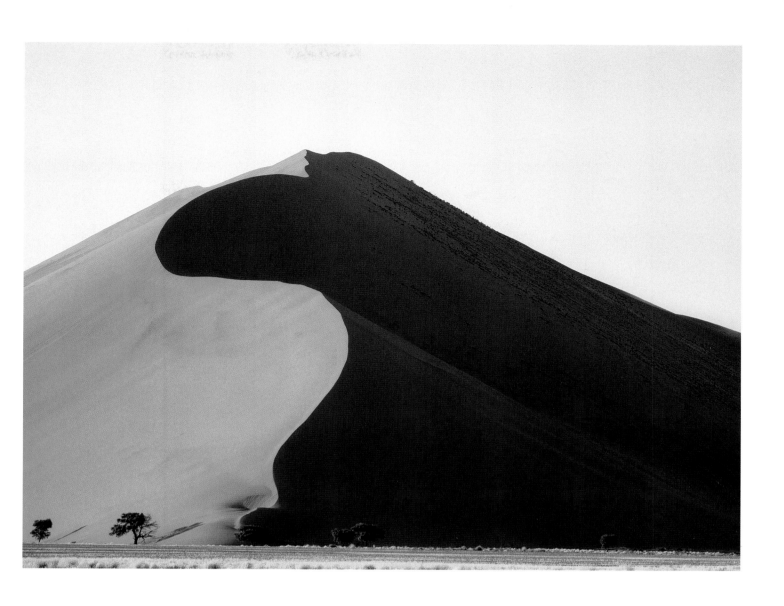

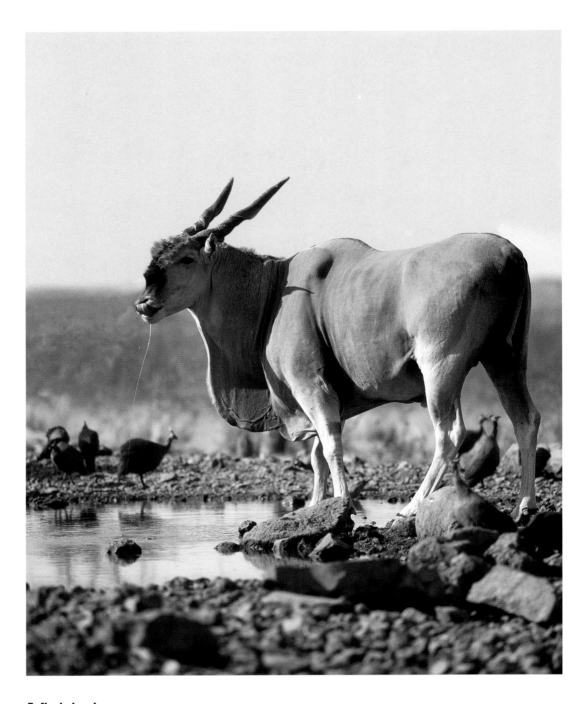

Reflected meters and incident meters sometimes give different readings of the same scene. A one-f/stop discrepancy is not uncommon. This drives me crazy. It's not impossible to resolve, but it can slow down your shooting and ruin good opportunities. (This kind of discrepancy can stem from choosing an incorrect middle-toned subject for a reflected reading or holding the meter at an incorrect angle for an incident reading.) One great advantage of automatic meters is that you can shoot fast without being burdened by exposure calculations.

For this composition of an eland bull at a water hole in northern Namibia, I used both metering methods to determine the correct exposure. The bull was facing away from the early-morning sun, creating shadows on his head and shoulders. I didn't want to lose detail in those shadows, yet I also didn't want to burn out the highlights in the sunlit portions of his body. I was in a blind camouflaged by thorn bushes, so to take an incident reading, I had to stick my hand with the meter into the sunlight without getting stabbed by the lethal thorns. The incident reading

was 1/250 at f/11. I then took a spot reflected reading on one of the middle-toned rocks in front of the water hole. This reading was 1/250 at f/8 plus 1/3, which would open up the shadows. I used both readings as insurance.

tech data: Both photos: Mamiya RZ 67 II, 500mm APO telephoto, Fujichrome Provia 100F, tripod. Above: 1/250, f/8 plus 1/3; right: 1/250, f/11.

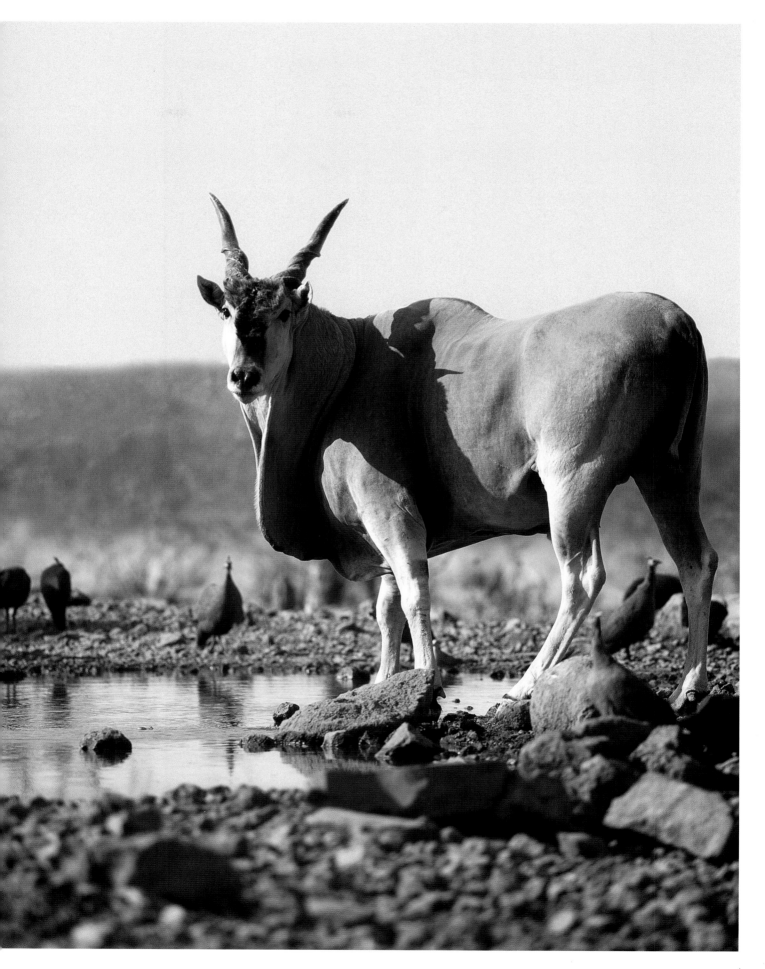

>>> chapter three
finding middle gray

finding middle [gray]

Some photographs don't have a middle-gray, or middle-toned, area. Photographing a baby harp seal on snow is an example. In those instances, you can't use a reflected meter to calculate the correct exposure unless you use another object, such as a gray camera bag, from which a reading can be taken.

Most pictures have middle-gray tonalities within the composition, but sometimes they are a challenge to recognize. A friend of mine tells me he is a nervous wreck when he tries to identify middle gray in a landscape because he's usually wrong and his exposures are consequently incorrect. Many of you, I know, have no intention of buying a handheld meter. But whether you use the TTL meter built into your camera or a hand-

held reflected meter, you will want to be able to correctly identify the middle-gray portion of each composition you capture on film.

I have designed this chapter to help you locate middle-toned portions of an image. Sometimes the area I use is very small; other times it's a larger percentage of the frame. The following pictures each have one or more circles that indicate the precise area of the photo from which I took a reflected reading to obtain the exposure. The encircled portion of each photo may not be exactly 18 percent gray, but it is close enough to provide an accurate exposure. (Eighteen percent is the accepted numerical value that indicates middle gray. It refers to the fact that 18 percent of the light striking the subject is reflected back into the lens.)

[opposite page]

Sunrise on Menton, France.

tech data: Mamiya RZ 67 II, 250mm telephoto lens, 1/60, f/8, Fujichrome Velvia, tripod.

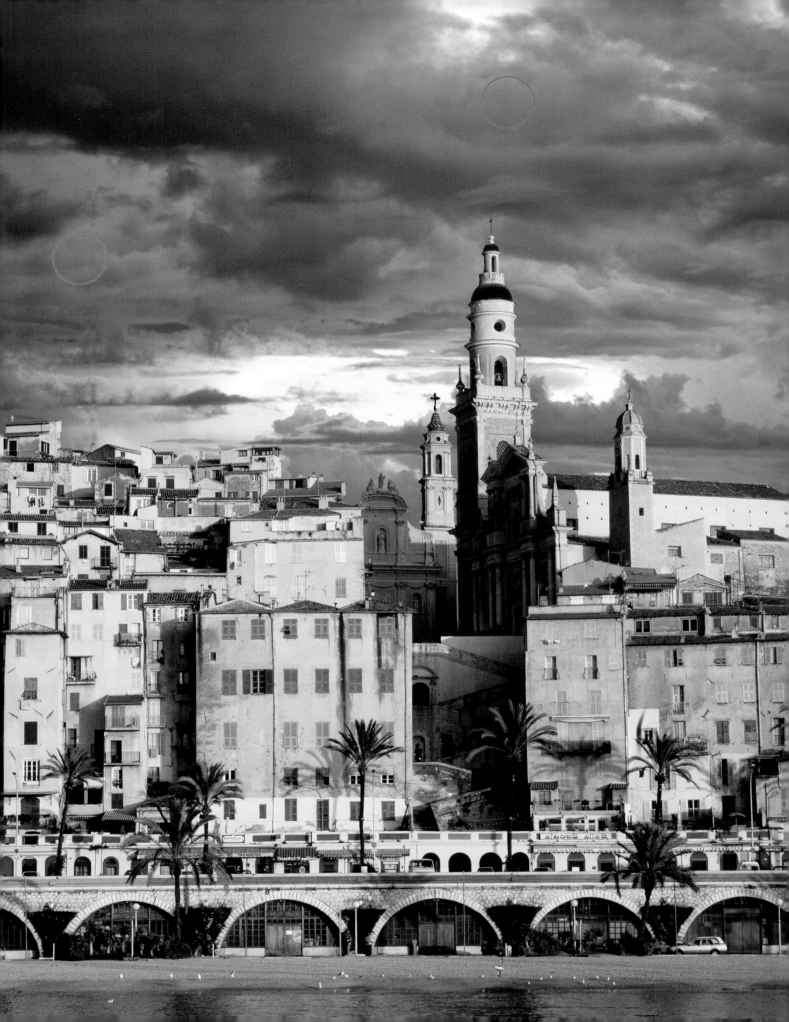

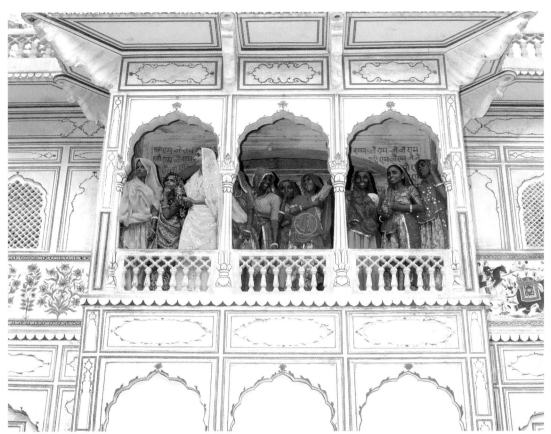

Women in Jaipur, India.

tech data: Mamiya RZ 67 II, 350mm APO telephoto lens, 1/60, f/5.6, Fujichrome Velvia, tripod.

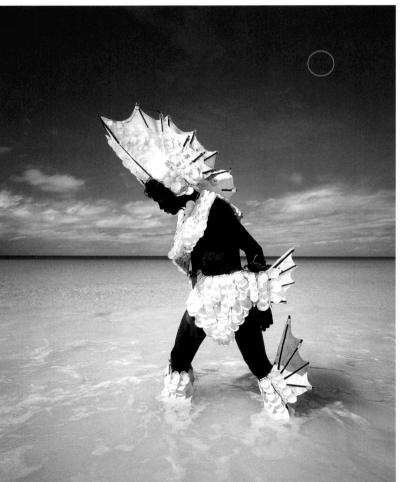

Carnival participant, Boracay Island, Philippines.

tech data: Mamiya 7, 43mm wide-angle lens, 1/125, f/8–f/11, Fujichrome Velvia, tripod with carbon fiber legs in saltwater.

[opposite page]

Sunset behind Motu, Bora Bora, Tahiti.

tech data: Mamiya RZ 67, 500mm APO telephoto, 1/125, f/6, Fujichrome Velvia, handheld on boat.

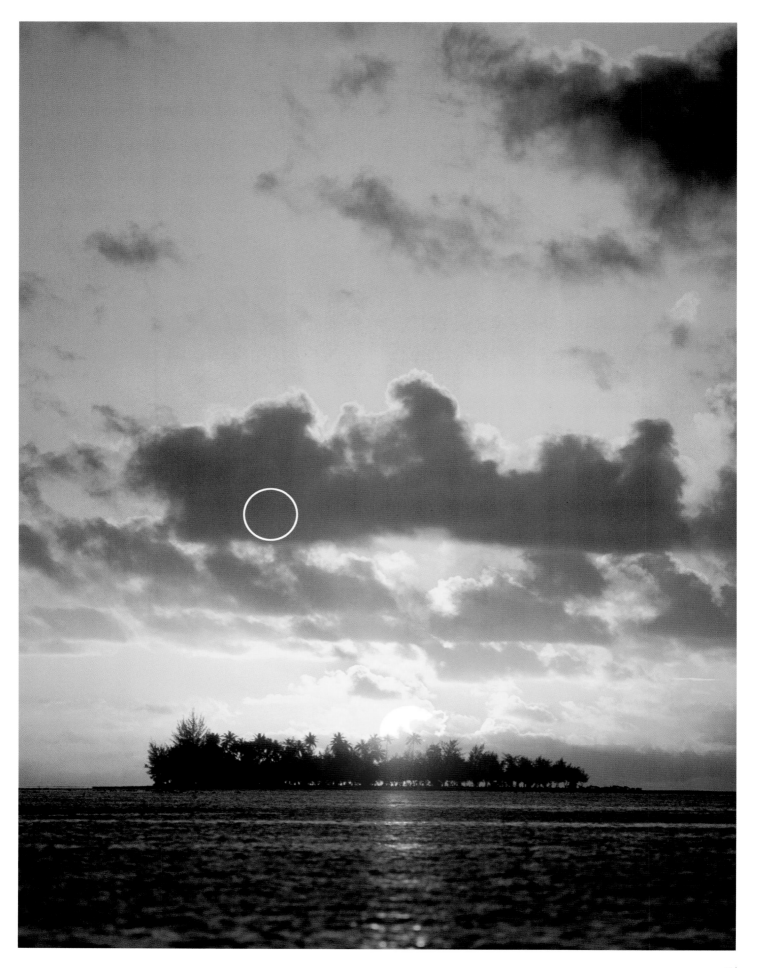

Merchant's Mill Pond State Park, North Carolina.

tech data: Mamiya 7, 43mm wide-angle lens, 1/2, f/22, Fujichrome Velvia, tripod pushed down into the muck of the swamp.

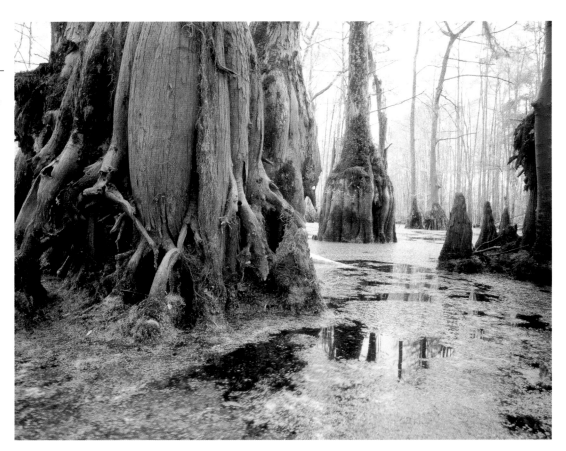

Arctic wolf, Canada.

tech data: Mamiya RZ 67 II, 500mm APO telephoto lens, 1/250, f/8–f/11, Fujichrome Provia 100, tripod.

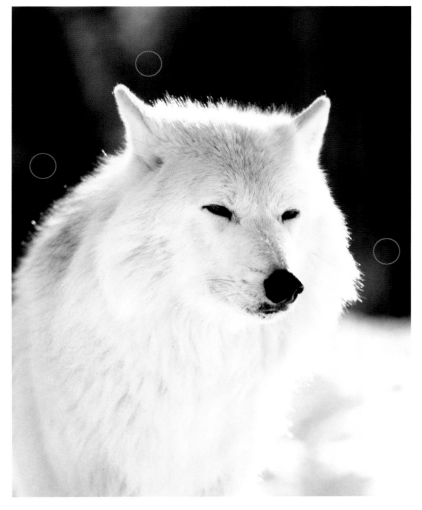

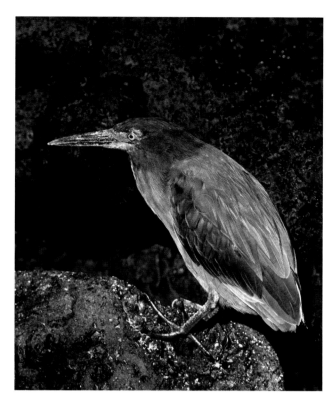

Lava heron, Galápagos Islands, Ecuador.

tech data: Mamiya RZ 67 II, 250mm telephoto lens, 1/250, f/5.6, Fujichrome Provia 100, tripod.

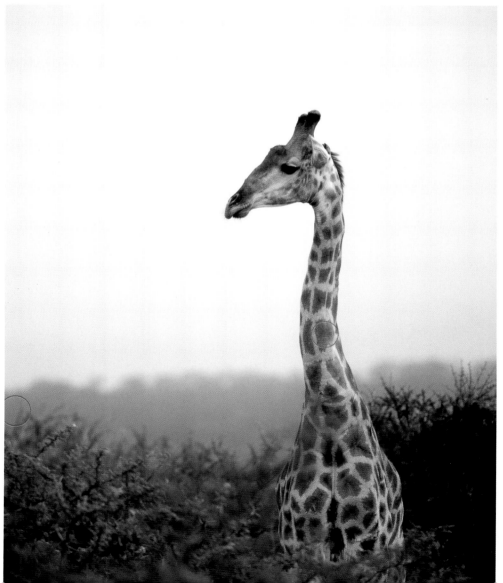

Giraffe, Kruger National Park, South Africa.

tech data: Mamiya RZ 67 II, 500mm APO telephoto lens, 1/125, f/6, Fujichrome Provia 100F, camera rested on beanbag in Land Rover.

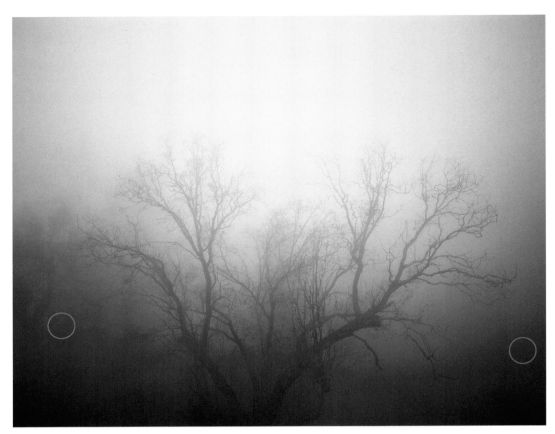

Tree in fog, Western Sierras, California.

tech data: Mamiya 7, 43mm wide-angle lens, one second, f/22, Fujichrome Velvia, tripod.

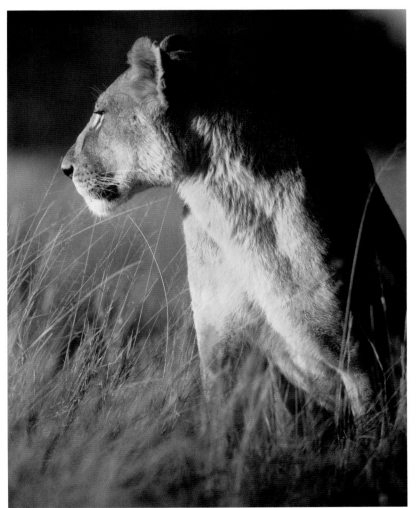

Lioness at sunrise, Savute Game Park, Botswana.

tech data: Mamiya RZ 67 II, 350mm APO telephoto, 1/125, f/5.6, Fujichrome Provia 100F, camera rested on beanbag in Land Rover.

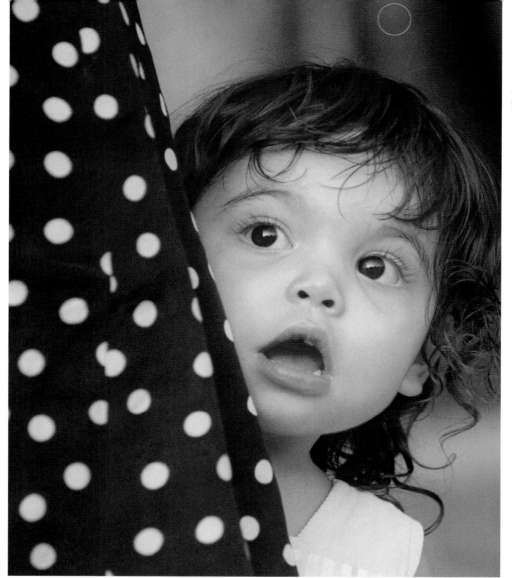

My neighbor's little girl, Northridge, California.

tech data: Canon EOS 1, 50–200mm zoom, 1/125, f/8, Fujicolor NPC 160, handheld.

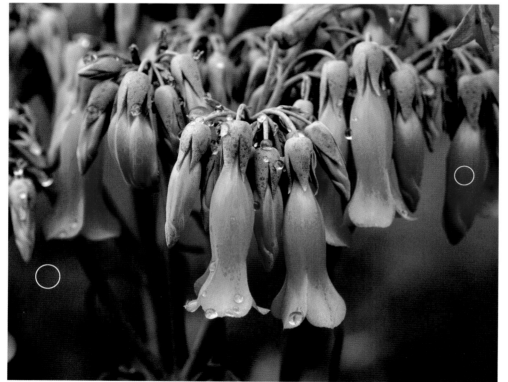

Flowers after a rain, Kruger National Park, South Africa.

tech data: Mamiya RZ 67 II, 50mm wide-angle lens, 1/2 second, f/22, Fujichrome Provia 100F, tripod.

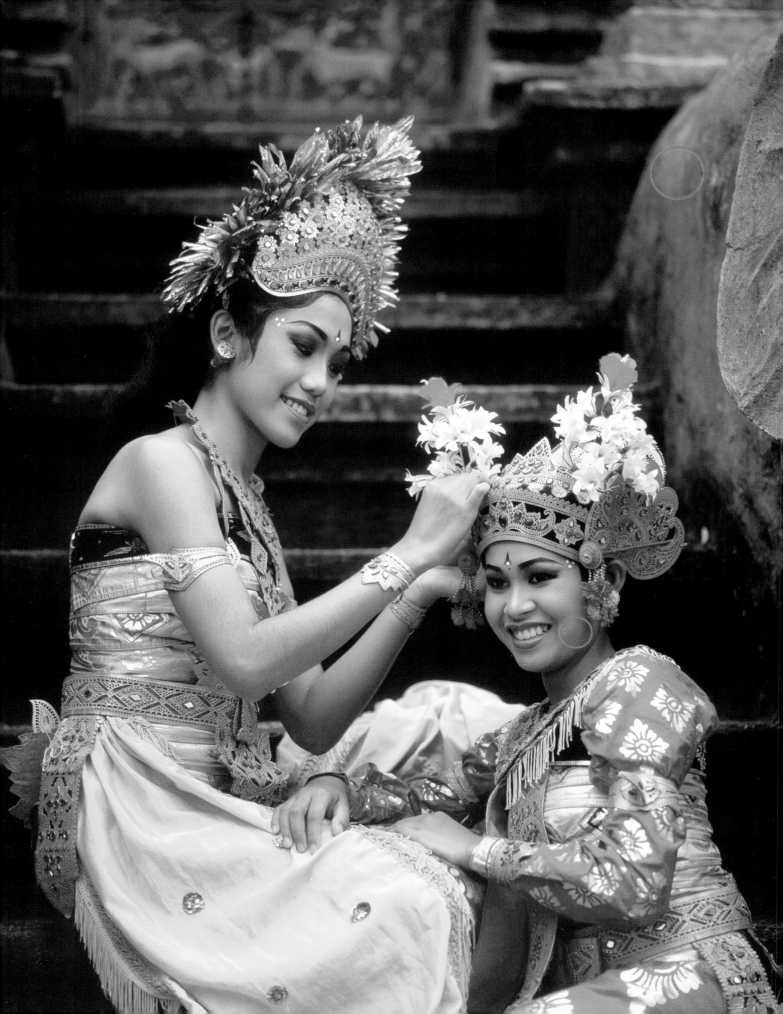

Alabama Hills and the Eastern
Sierras, California.

tech data: Mamiya 7, 43mm wide-angle lens,
1/8, f/5.6–f/8, Fujichrome Velvia, tripod.

[opposite page]
Balinese dancers, Bali, Indonesia.

tech data: Mamiya RZ 67 II, 250mm telephoto,
1/60, f/4.5, Fujichrome Velvia, tripod.

exposing for snow

exposing for [snow]

here is the chapter you've been waiting for. When I lecture or conduct workshops or photo tours, I get more questions about photographing on snow than any other aspect of photography. If you follow the guidelines here, you'll never again be insecure about shooting winter landscapes.

Automatic exposure systems seduce you into relying on them because they're fast, effortless and accurate much of the time. But then they betray you just when you have a once-in-a-lifetime image in the viewfinder. It's time to rethink the whole process.

The number one question in my seminars is, "How do you expose for snow?" Usually it's phrased as, "Do you take a light reading and then open up one and a half f/stops?" I always answer, "No, I don't do it that way." And here's why: There are many kinds of snow, and many types of compositions with snow in them. There's patchy snow, dirty snow, fresh powder and crusty snow. There's snow under an overcast sky, snow with midday sunshine, and snow at sunset with the low-angled light grazing the landscape. How, then, can there be a general rule to follow when exposing for snow? You can't tell me that all these situations require the same type of compensation.

There are only two methods that will produce precise exposures in all types of snowy conditions. These methods have nothing to do with compensation, i.e., taking a light reading and then adjusting the lens aperture or shutter speed to account for snow. Instead, there's no guesswork at all.

Method #1: Use an incident light meter, pointing the hemispherical white dome at the camera. If the meter is in the same light as the subject, the exposure will be correct.

Method #2: Use a reflected meter, either a handheld model or the TTL meter in your camera, and read a middle-toned object. This could be tree bark, a gray cloud, an animal or a camera bag. With the camera on manual mode (or with the exposure lock button depressed), use that exposure information, and take the picture.

Before you find yourself in a whiteout without a middle-toned object to read, I suggest buying a Kodak gray card for a few dollars. Then go to a fabric store and buy a small piece of material that matches the card. Sew that fabric onto your camera bag, backpack or photo vest. Now, wherever you are, you'll have a middle-toned object.

In the following pictures I used one of these two methods to determine exposure. Each situation is a variation on the same theme. Showing so many examples might seem repetitive, but when you're finished reading this chapter, you should be fully confident in your ability to produce perfects exposures on snow.

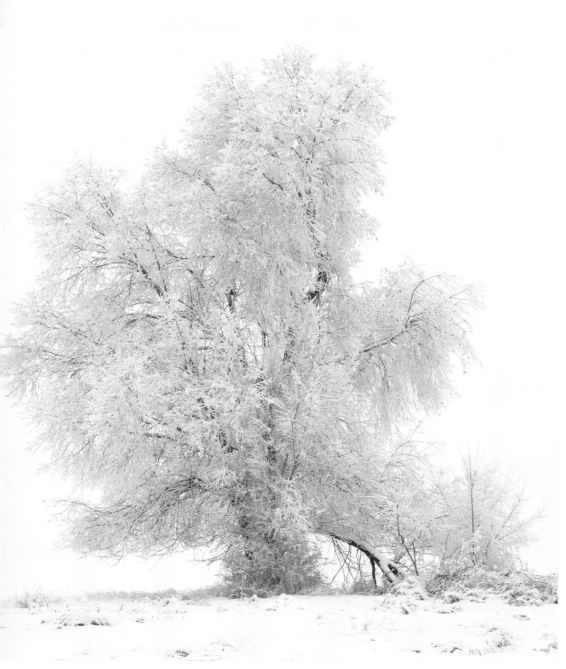

This is the classic whiteout. There are virtually no middle tones in this picture at all. Had I taken a normal light reading with a TTL meter, even with the technologically advanced matrix or evaluative systems, the automation would try to make this a medium-gray picture and, as a result, underexpose it. In other words, I would have thrown it away.

Instead, I used an incident meter to read the light falling during this Montana snowfall. The light was uniformly soft, which meant that no matter where I took the reading, the meter was in the same light as the tree.

tech data: Mamiya RZ 67 II, 110mm normal lens, 1 second, f/32, Fujichrome Velvia, tripod.

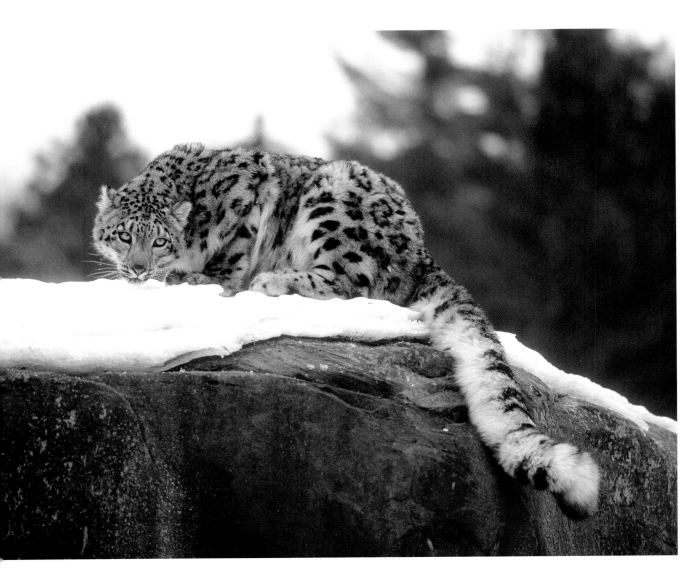

This shot of a crouching snow leopard is a very different situation, yet one involving snow. The white sky and the snow on the rock face are only a fraction of the entire frame. Most of the picture consists of middle-toned objects. The often-taught rule of taking a light reading with a TTL meter and opening up one and a half f/stops wouldn't apply here. So, the question is, How much snow is required before you use this rule?

The safest way to take an accurate reading is to use one of the two methods described above. I used a handheld incident meter, but I also could have taken a spot reading on the trees in the background or on a middle-toned portion of the rock.

tech data: Mamiya RZ 67 II, 500mm APO telephoto lens, 1/125, f/6, Fujichrome Provia 100 pushed one f/stop to 200, tripod.

Backlighting on snow and ice is always a tricky situation. The frozen crust on the shore of Lake Superior in Minnesota was reflecting a somber yet contrasty sky. An incident meter cannot be used to read backlighting, and an automated TTL metering system might provide a proper exposure—but then again, it might not. It's hard to tell. Yes, you can take the shot recommended by the camera's meter and then bracket all over the place. You'll definitely get at least one shot that's correct. But I prefer not to guess.

I used a spot meter to read the neutral gray portion of the clouds. I knew that when any middle-toned subject is in fact reproduced as middle-toned, everything else—including the highlights and shadows—falls into place correctly.

tech data: Mamiya 7, 43mm wide-angle lens, 1/4, f/22, Fujichrome Velvia, tripod.

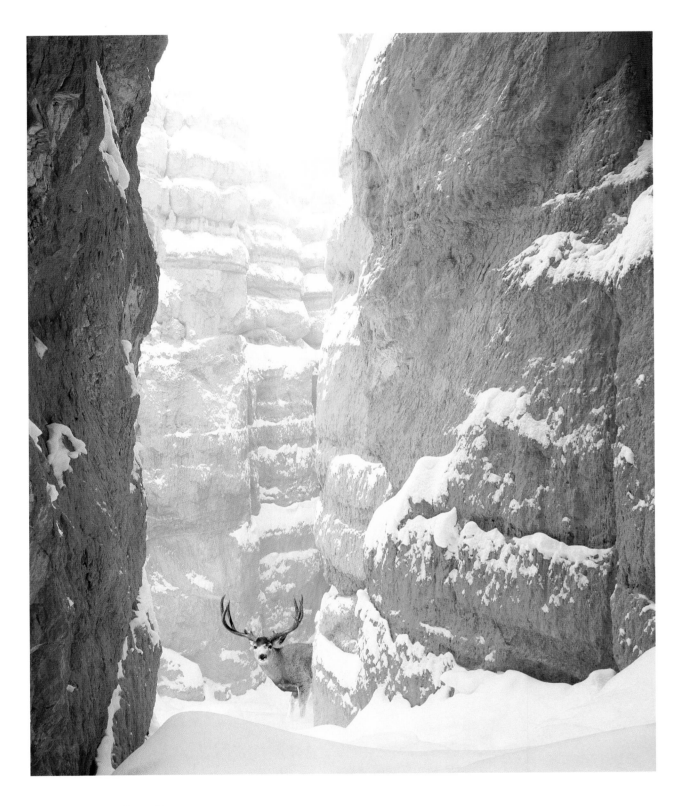

Bryce Canyon National Park is about 8,000 feet in elevation, and sometimes during the winter low clouds partially shroud the orange cliffs. This, combined with the snow, provides another challenging exposure situation. Will a TTL meter be fooled by the fog? How much must there be before you no longer trust your in-camera meter?

These are the questions that constantly plague photographers who rely on automation. When I shot this picture of a mule deer in Bryce, I quickly took a reflected reading off a middle-toned area of the orange sandstone. Then, I used that exposure data to make the shot. I was afraid to use the incident mode on the Sekonic L-508, because the light in which I was standing was not exactly the same as the light falling on the deer.

tech data: Mamiya RZ 67 II, 250mm telephoto lens, 1/60, f/4.5, Fujichrome Velvia, tripod.

This shot was taken at Bryce Canyon an hour before the previous one. A reflected meter's ability to read a narrow angle is evident in evaluating the exposure for this landscape because the middle-toned portions of the image are like small islands surrounded by whiteness. Using the one-degree spot capability of the Sekonic L-508, I read the orange sandstone to make the shot.

Alternatively, had I been shooting 35mm, I would have put the longest lens I had on the camera and switched to spot metering. After taking the reading, I'd put the wide-angle back on to make the shot and remember, of course, to put the camera on the manual exposure mode. I would then set the lens and shutter speed with the exposure data obtained from the spot reading.

tech data: Mamiya 7, 43mm wide-angle lens, 1/8, f/22, Fujichrome Velvia, tripod.

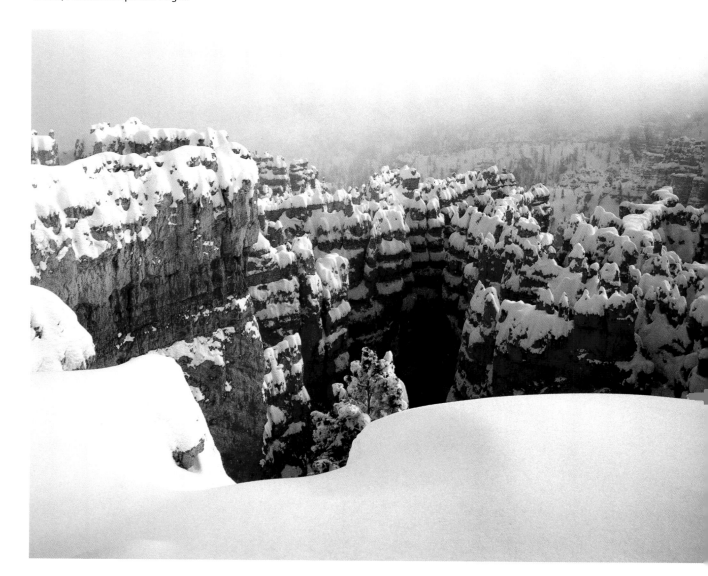

When using a handheld meter, you cannot respond to an exposure situation as fast as when using a TTL meter, which basically evaluates the light instantly. When shooting wildlife, this can be a serious disadvantage since milliseconds can mean the difference between getting a shot and missing it.

When the light is uniform and unchanging, however, as it was the day I spotted this mountain lion slinking behind a snow bank, I can take an incident light reading and know that the exposure information isn't going to change for a while. Sometimes, the same light reading is good for several hours.

TECH DATA: Mamiya RZ 67 II, 500mm APO telephoto lens, 1/125, f/6, Fujichrome Provia 100F, tripod.

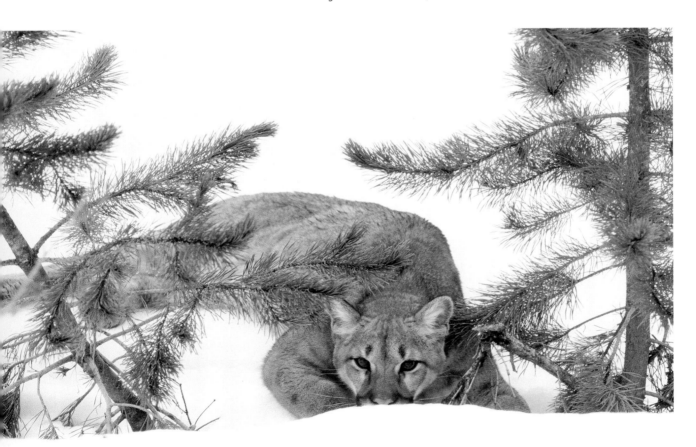

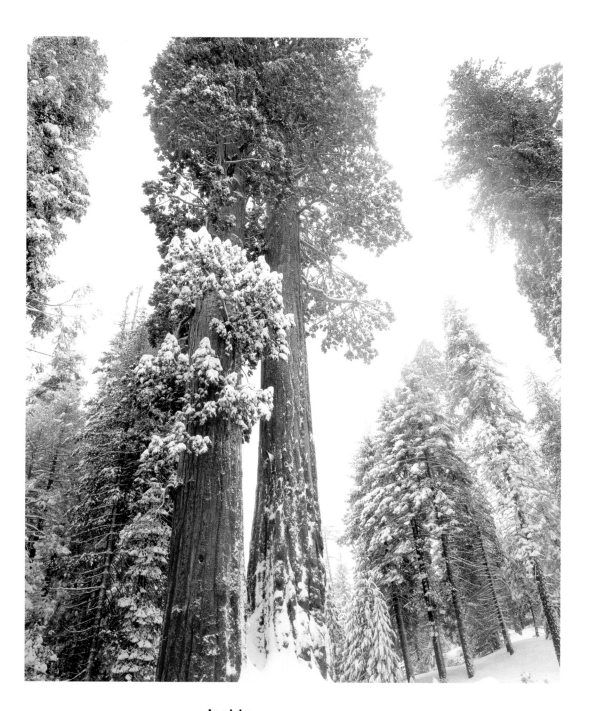

In winter, you have to be concerned about more than snow. The sky is often blindingly bright, and this will also throw your TTL meter into a tizzy. Because automatic metering systems are influenced by the amount of light reflecting back into the lens from the various elements in the composition, they are fooled by varying amounts into producing inaccurate exposures. The difficult-to-answer question is, How much is the meter deceived?

The solution always involves using one of the two exposure methods defined previously: Take a reading using an incident meter or a reflected meter (handheld or in-camera), with a gray card if necessary. Here, I took a reflected spot reading on the bark of the giant Sequoia trees I photographed during a snowstorm in California's western Sierras.

tech data: Mamiya RZ 67 II, 50mm wide-angle lens, 1 second, f/22, Fujichrome Velvia, tripod.

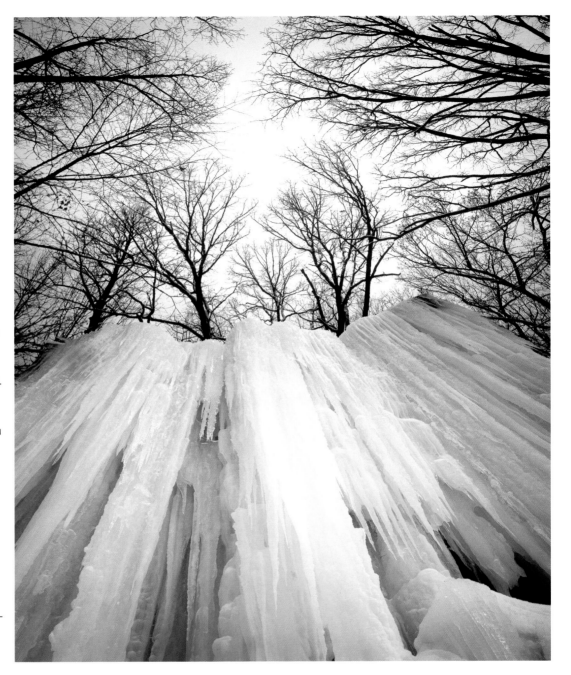

I shot this icefall in the Upper Peninsula of Michigan the day before ice climbers hacked it to pieces. It was a lucky find.

The camera I used for this shot was the Mamiya 7, which has a TTL meter built in. It is just as accurate as meters in 35mm cameras, but it is also just as vulnerable to being deceived. Here, the white-blue ice and the bright sky would cause underexposure for sure. I know there are those of you who are still thinking, Well, I could open up one f/stop to compensate. But then, after you open up a stop, you will still bracket your exposures because you are not absolutely sure that the one f/stop adjustment is correct. Is it really three-quarters of an f/stop? Or perhaps one and a half stops?

I quickly and easily obtained a correct reading with a handheld incident meter. No guessing, no insecurity, no waste of film.

tech data: Mamiya 7, 43mm wide-angle lens, 1/2, f/22, Fujichrome Velvia, tripod.

Notice the sidelighting in this picture of a young pine tree. When you use an incident meter, don't point the white hemispherical dome at the light source. Point it at the camera lens. The light emanating from the sun should strike the meter exactly as it illuminates the subject. If the dome is directed toward the lens, the sunlight will sidelight the white dome as it does the tree and snow. This tells the meter how much ambient light there is, which in turn provides a perfect exposure.

Having said this, you can, in fact, tweak the exposure reading depending on your artistic vision. If you angle the meter slightly toward the sun, you will underexpose the scene a bit. (The meter receives more light and indicates a smaller lens aperture or faster shutter speed.) Perhaps you want additional detail in the texture of the snow. If you angle the meter a few degrees away from the sun, the opposite occurs. You lighten the scene slightly.

tech data: Mamiya RZ 67 II, 250mm telephoto lens, 1/4, f32–f/45, Fujichrome Velvia, tripod.

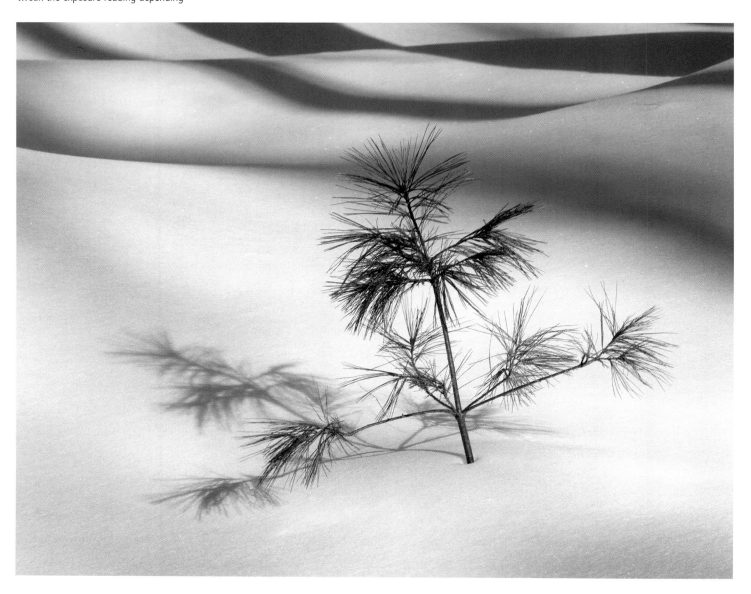

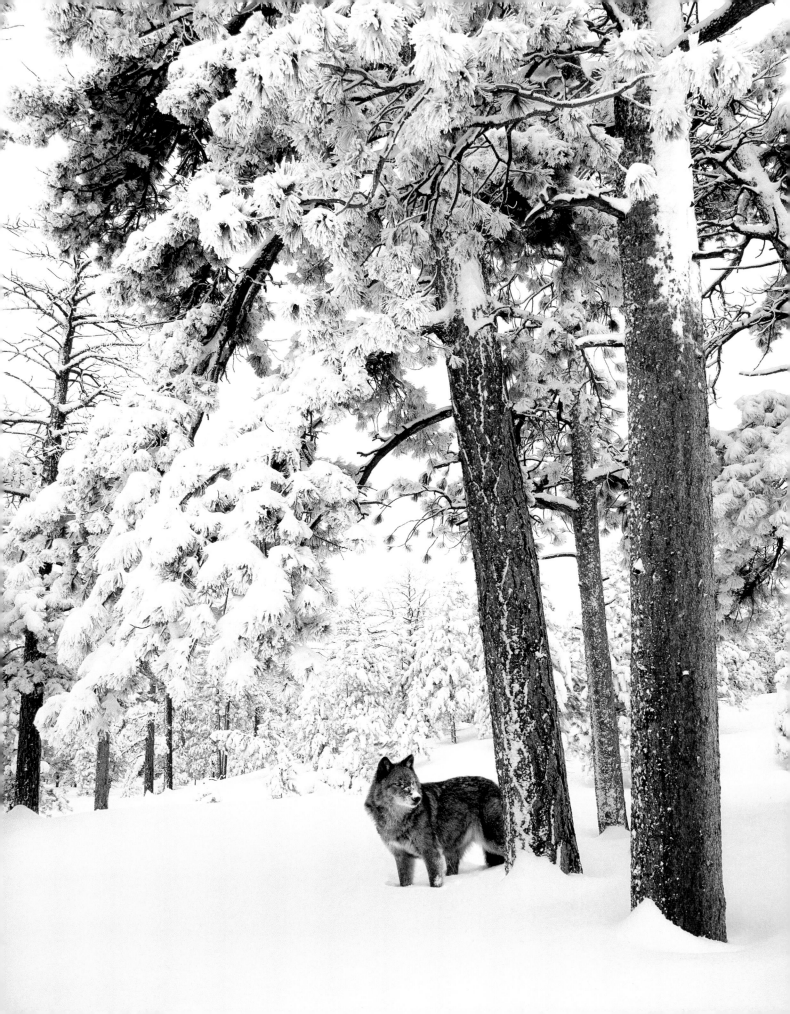

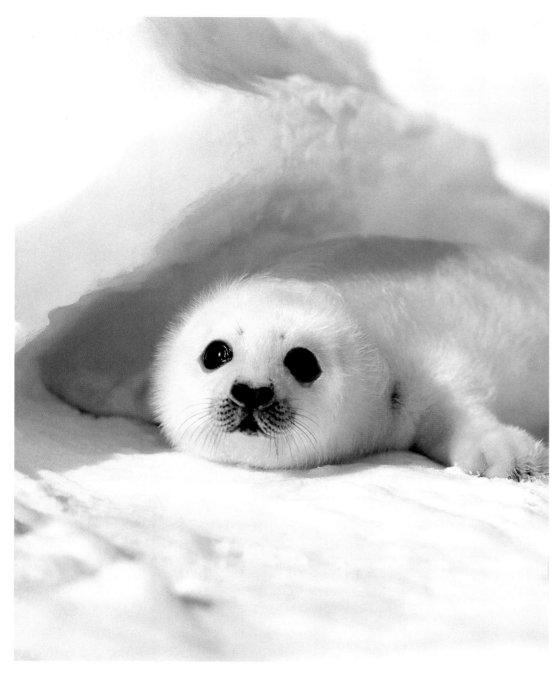

Once in a while, I will double-check my meter readings by comparing the reflected data with the information I get from the incident mode. When I shot this baby harp seal near the Magdalen Islands north of Nova Scotia, Canada, I was in a world of snow and ice with a low-angled midday sun. I wanted to make sure my readings were correct. I took this before the Sekonic L-508 came out. I was using two meters then: the Minolta IV incident and the Minolta F spot meter. With the IV, I read the light falling onto the scene. With the handheld spot meter, I read a gray piece of fabric (that matched a gray card in tonality) sewn onto my camera backpack. I made sure the fabric was angled to the sun in the way the seal was. I was delighted to see that both readings were within two-tenths of an f/stop of each other.

I was amazed that even in the 45 degrees-below-zero weather, both of the meters and my medium format equipment worked well.

tech data: Mamiya RZ 67, 250mm telephoto lens, 1/250, f/8, Fujichrome Provia 100, tripod.

[opposite page]

There are several components in this image that required detail: the wolf, the tree bark and the snow-laden needles. The snow itself was virtually devoid of detail. I could have taken reflected readings from several middle-toned portions of the scene, but this would have taken too much time and effort. I took a single incident reading, knowing that if this was correct, all of the tonal values would fall into place. I made no compensation for the black fur of the wolf because I thought the snow would bounce just enough light onto the animal to make it work.

tech data: Mamiya RZ 67 II, 110mm APO normal lens, 1/60, f/5.6, Fujichrome Provia 100F, tripod.

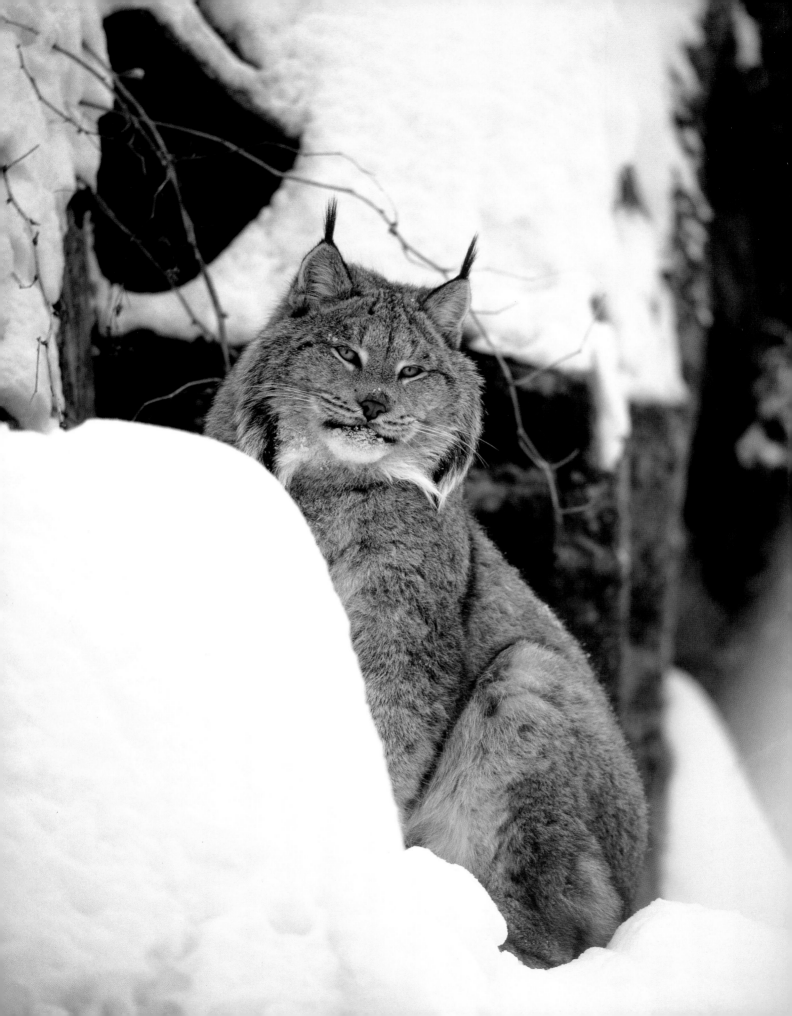

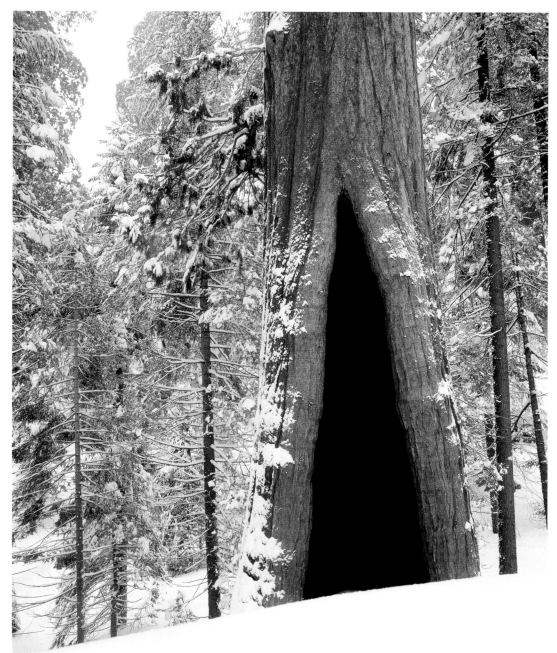

Even when the light level is so dim you can hardly see the watch on your wrist, pictures can be taken with a proper exposure. Light is cumulative. The longer the shutter is open, the more light builds up on film. I used a handheld reflected meter to read this composition of a giant Sequoia. I opted not to use the incident mode because, although it is very accurate, it tends to result in exposures that simulate what you see with your eyes. The light here was extremely dim—it was twilight under a low cloud cover. I didn't want a dark picture. So, I took a reading with the spot mode on the tree bark and made the picture.

Any 35mm camera and TTL meter could have come out with the same result, provided the light reading was taken with the spot mode in conjunction with a telephoto lens.

TECH DATA: Mamiya RZ 67 II, 50mm wide-angle lens, 8 seconds, f/32, Fujichrome Velvia, tripod.

[opposite page]

This shot of a Canadian lynx presents a unique situation in a wintry environment. You could use the animal itself as a gray card. If the cat is exposed correctly, then everything else will fall into place with the right amount of exposure. Of course, you'll have to switch to the spot mode in your camera and make sure that the lynx is composed in the center of the frame, which is the area from which this spot exposure was taken.

tech data: Mamiya RZ 67 II, 500mm APO telephoto, 1/125, f/6, Fujichrome Provia 100 pushed one f/stop to 200, tripod.

exposing for
backlighting

exposing for
[backlighting]

i n the previous chapter, I explained how exposure for snow photography cannot be reduced to a single axiom. No one rule governing exposure applies to all compositions. The same is true for pictures where the light source is in front of you. Whether you are shooting a backlit subject or are exposing for the light source itself (such as a sunset), there is no one rule that, when applied, gives perfect exposures for all possible scenarios.

Like winter photography, exposing for backlighting isn't difficult. It just takes a little thought. And, it requires a realization that automatic exposure modes cannot be relied upon. Automatic metering is a wonderful tool as long as you are constantly monitoring each composition to determine whether the TTL meter will provide an accurate exposure. It is you, ultimately, who must assess each situation.

An incident light meter cannot be used to read sunrises and sunsets. It reads light that is falling upon a scene. Said another way, it reads the light emanating from the light source, not the source itself. When you shoot the sun near the horizon, or the glowing clouds that it illuminates, you are actually photographing the light source. You can use only the TTL meter in your camera or a handheld reflected meter to determine the exposure of a sunrise and sunset.

All other backlighting situations can be handled by both incident and reflected types of meters as I illustrate in the examples that follow.

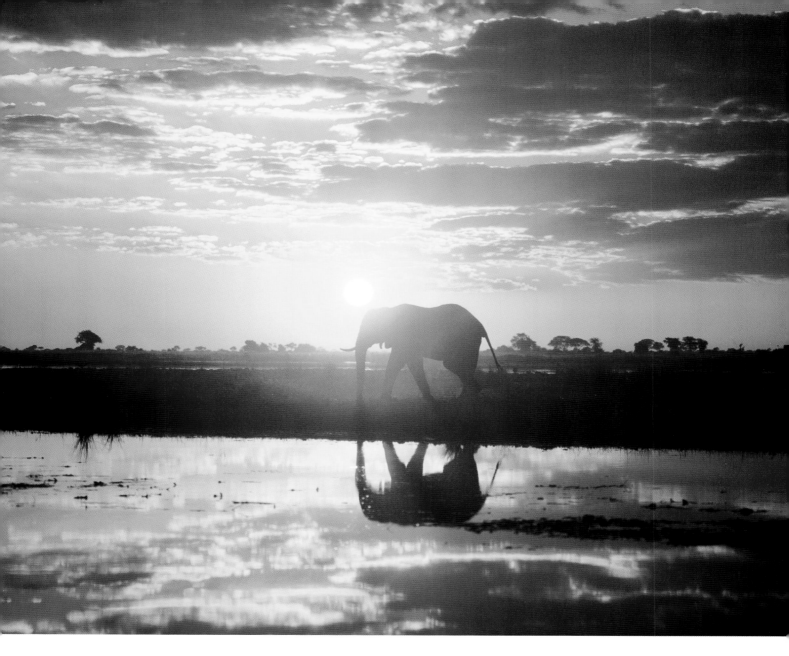

[opposite page]

Exposing for a beautiful sunset like this one is easy. Most of the tones are close to middle gray, so any TTL meter would give you an accurate reading. Aperture priority, shutter priority, matrix (or evaluative) metering, and even the program mode would work. Alternatively, you could use a handheld reflected meter and take a one-degree spot reading on one of the middle-toned clouds.

tech data: Mamiya RZ 67, 250mm telephoto, 1/15, f/5.6, Fujichrome Velvia, tripod.

Shooting into the sun itself presents a problem. It is so brilliant that it forces the meter reading into underexposure. This is particularly true when the sun is in the center of the composition, where most automatic meters take a large percentage of their data. If you use a wide-angle lens for a frame where the sun is very tiny, it will have less impact on the reading. If the sun is large, as it is with a long lens, it will overwhelm the meter, turning everything except the sun dark.

As you can see in this picture of an elephant in Chobe Game Reserve, Botswana, there is in fact detail in the gradations of color in the land and the animal. Instead of relying on automatic metering, I took a spot meter reading on a neutrally toned portion of the clouds and then used that reading for the shot. It is true that this technique takes a few more seconds to execute, and in those few moments things change—like a moving elephant. But what good is a picture if the exposure is wrong? Take the time to do it right.

tech data: Mamiya RZ 67 II, 250mm telephoto lens, 1/250, f/5.6, Fujichrome Provia 100F, camera rested on photo backpack in Land Rover.

When you expose for a bright sky, the much darker elements in the frame often go black. When you use an automatic exposure mode, and the silhouetted objects are very large in the frame—like this unusual composition on the Oregon Coast—the meter wants to make the rock and tree middle gray. This, in turn, overexposes the sky.

How do you solve this problem? Take a spot meter reading either with the TTL spot mode in your camera or with a handheld spot meter on the area in the frame that you want to be middle toned. I used the gray-purple clouds just to the left of the rock's pinnacle. Using this exposure data gave me the picture you see here. Note how the rock and tree are silhouetted—as they should be—and the sun and the glowing clouds are also properly exposed. When you expose for the middle tones in a picture, everything else always falls into place.

tech data: Mamiya RZ 67, 250mm telephoto, 1 second, f/45, Fujichrome Velvia, tripod.

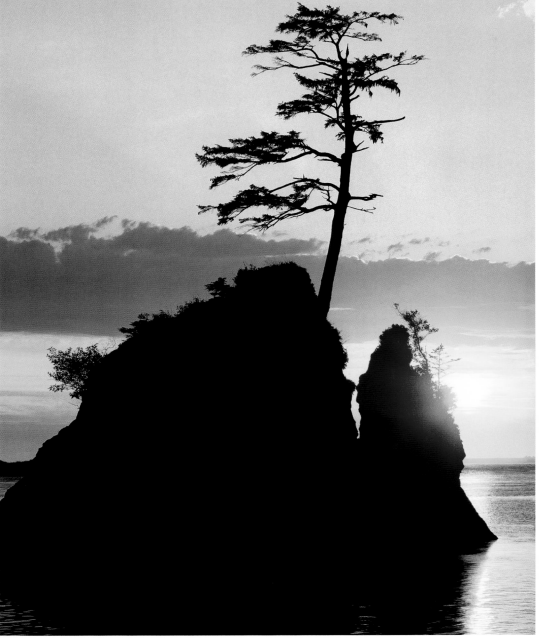

[opposite page]

Shooting into a brilliant sun with a telephoto lens means the sun and its surrounding halo will be large in the frame. Every metering mode will make this a silhouette because the meter interprets the bright light as medium gray. All middle-toned elements will become black shapes as a result.

Notice the detail in the the Taj Mahal here. The tomb isn't a featureless silhouette. Why? I didn't let a TTL meter dictate the exposure. I took control of the situation by metering a darker area of sky—one not in the composition. I used the L-508's spot meter mode to read part of the sky about one f/stop brighter than middle gray. I wanted a partial silhouette.

Because I chose an area a little lighter than middle gray, the meter underexposed the picture enough to darken the sky and reduce exposure on the building while retaining some detail in the intricate architecture.

Finding the right tone for a specific exposure comes with experience, but remember that the lighter the area you meter, the darker your resulting picture. A middle-toned area will render the Taj correctly exposed but will blow out the sky. To reduce the exposure in the final image, take the reading from an area of the sky a little brighter than middle gray. This will help you predictably tweak meter readings.

tech data: Mamiya RZ 67, 350mm APO telephoto, 1/60, f/11, Fujichrome Velvia, tripod (no filter).

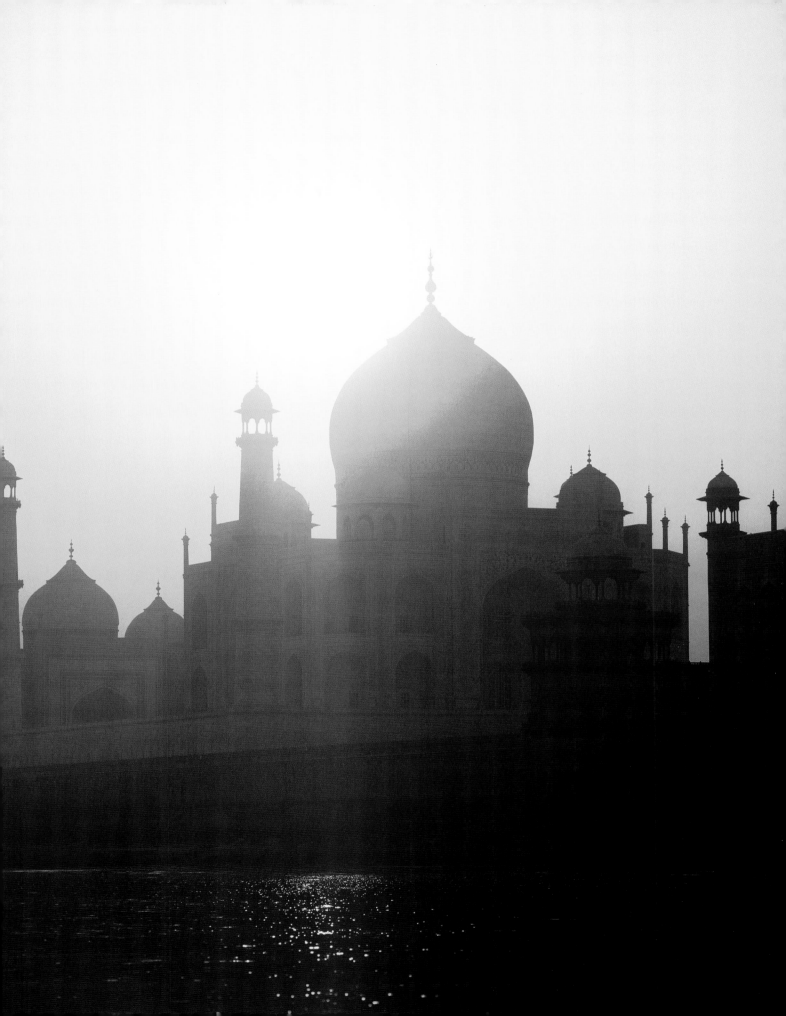

Sunrise and sunset skies vary tremendously. This dawn sky behind a Joshua tree in California doesn't have the striking contrast between highlight and shadow that the previous three photos do. Instead, the entire sky is virtually a middle tone. Over the next fifteen minutes, as the sun broke the horizon, this changed dramatically. But here any TTL meter behind your lens would give you a correct exposure. Exposing for the sky renders the tree as a partial silhouette.

tech data: Mamiya RZ 67 II, 110mm normal lens, 2 seconds, f/22, Fujichrome Velvia, tripod.

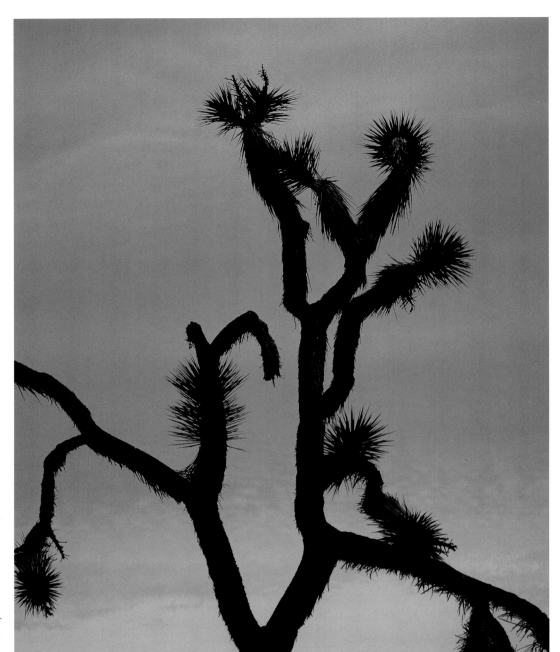

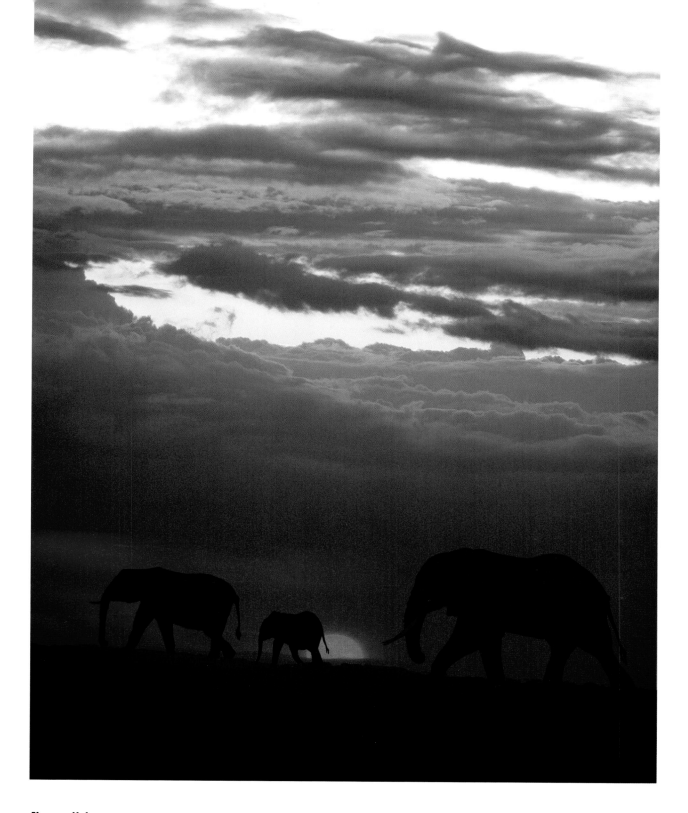

Fine particles of haze or dust mute the sun to such a degree that it no longer adversely affects a meter. When I was shooting in Europe a few years ago, I remember the light from a low-angled sun was so diffused by atmospheric haze that it didn't even cast shadows.

I could have exposed this shot in Kenya with a TTL meter. The sun, only half visible, was so diminished by airborne particles that it really wasn't a factor in the exposure. If you want to use a handheld reflected meter to determine the exposure, as I did, it's a simple matter of taking a spot reading on the clouds.

tech data: Mamiya RZ 67 II, 350mm APO telephoto lens, 1/125, f/5.6, Fujichrome Provia 100 pushed one f/stop to 200, camera rested on beanbag in Land Rover.

The inclusion of the morning sun in this shot of Bryce Canyon would normally underexpose the landscape if you used a TTL meter. There are three reasons why the sun in this particular composition doesn't do that:

1. It is partially hidden behind the tree trunk, reducing the amount of light reaching the meter.

2. The wide-angle lens made the sun appear smaller than it does to the unaided eye, thus affecting the meter less. (The 50mm RZ lens I used here is approximately comparable to a 24mm lens in the 35mm format.)

3. The placement of the sun in the frame is off center, which diminished its influence on the meter since the meter takes most of its data from the center of the frame.

The conclusion then is that the scene requires no compensation. Three-quarters of the frame is medium toned, so the TTL meter should perform correctly. To be sure, of course, you can take a spot reading on a middle-gray area of the scene with the spot mode in your camera (while you use a telephoto lens to narrow what the meter sees) or a handheld meter.

Should I have used a split neutral density filter to darken the sky? I would say no, because it would have darkened the upper portion of the tree as well and made it look unnatural.

tech data: Mamiya RZ 67 II, 50mm wide-angle lens, 1/8, f/32, Fujichrome Velvia, tripod.

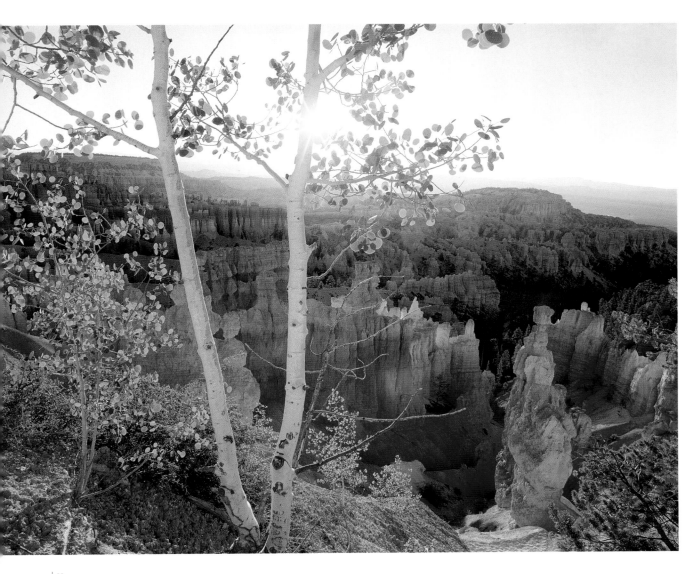

In a composition where a white sky fills a small portion of the frame, particularly if it's away from the center of the picture, the bright area will have little impact on the reading. In fact, it might not adversely the meter reading at all. This shot in the western Sierras in California presented an interesting situation. The foliage was very dark; the sky in the distance was several f/stops brighter.

Would it affect the reading? A matrix metering would probably give you accurate exposure data. Still, to be sure, I used an incident meter to give me the unambiguous reading. Alternatively, I could have used a reflected meter to read a middle-toned portion of the tree.

tech data: Mamiya 7, 43mm wide-angle lens, 1 second, f/22, Fujichrome Velvia, tripod.

An egret in an adjacent tree was also backlit, but the circumstances were different. Here I had some medium-gray areas from which a reflected reading could be made. That made it a lot easier to determine the precise exposure.

tech data: Mamiya RZ 67 II, 500mm APO tele-photo, 1/250, f/5.6, Fujichrome Provia 100F, tripod.

Strong backlighting that creates dramatic contrast between highlights and shadows offers the photographer a number of possibilities. You can expose for the highlights, underexposing the shadows, or you can retain the detail in the shadow areas and blow out the highlights.

In this ice cave on Michigan's Upper Peninsula, I chose the latter. I wanted detail in the rock as well as the blue color in the foreground ice. As a result, though, I lost saturation in the center column of ice. I took a reflected reading off the rock surface.

tech data: Mamiya 7, 43mm wide-angle lens, 2 seconds, f/22, Fujichrome Velvia, tripod.

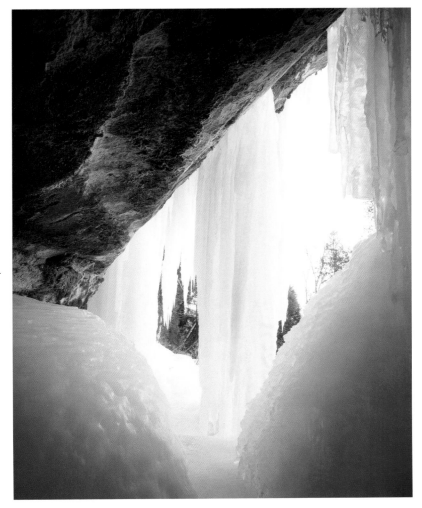

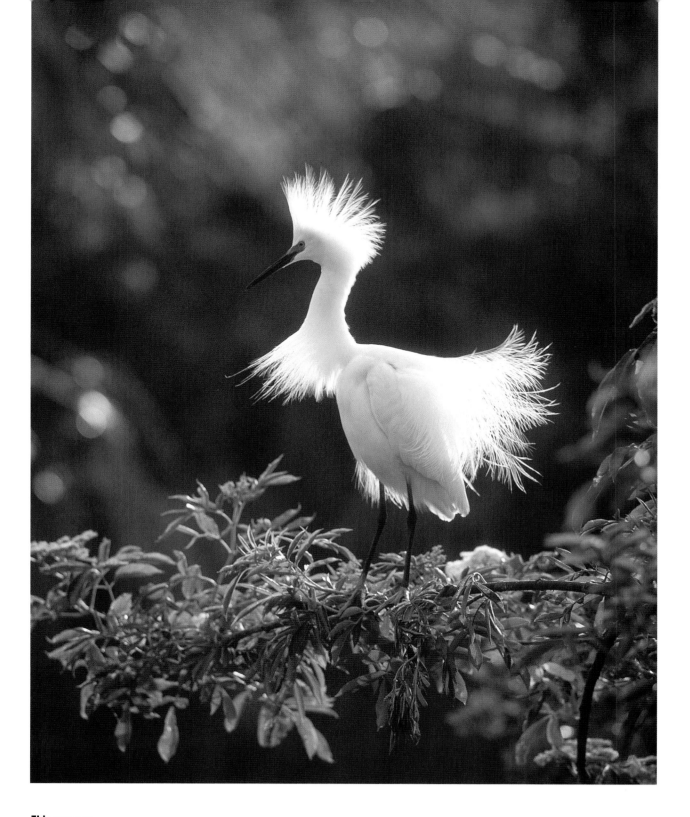

This was an especially tricky back-lighting situation because the sunlight was passing through the white feathers of this egret in Florida. In addition, a bird in motion gives you no time to think. That has to take place before the bird takes flight. A TTL meter would work sometimes, but as I have explained, I want a guarantee that I have the proper exposure rather than depending on programmed electronics and hope for the best.

I didn't see a medium-toned area in the immediate composition to use for a reflected reading. Incident meters don't work for backlighting unless you don't care about the background. In this shot, I wanted both the bird and the foliage to be correctly exposed within the film's limitations. Therefore, my only option was to use the sunny f/16 rule (see pages 132 and 140). I determined the light required about a 1/2 f/stop increase from bright sun.

tech data: Mamiya RZ 67 II, 500mm tele-photo, 1/30, f/22, Fujichrome Provia 100F, tripod.

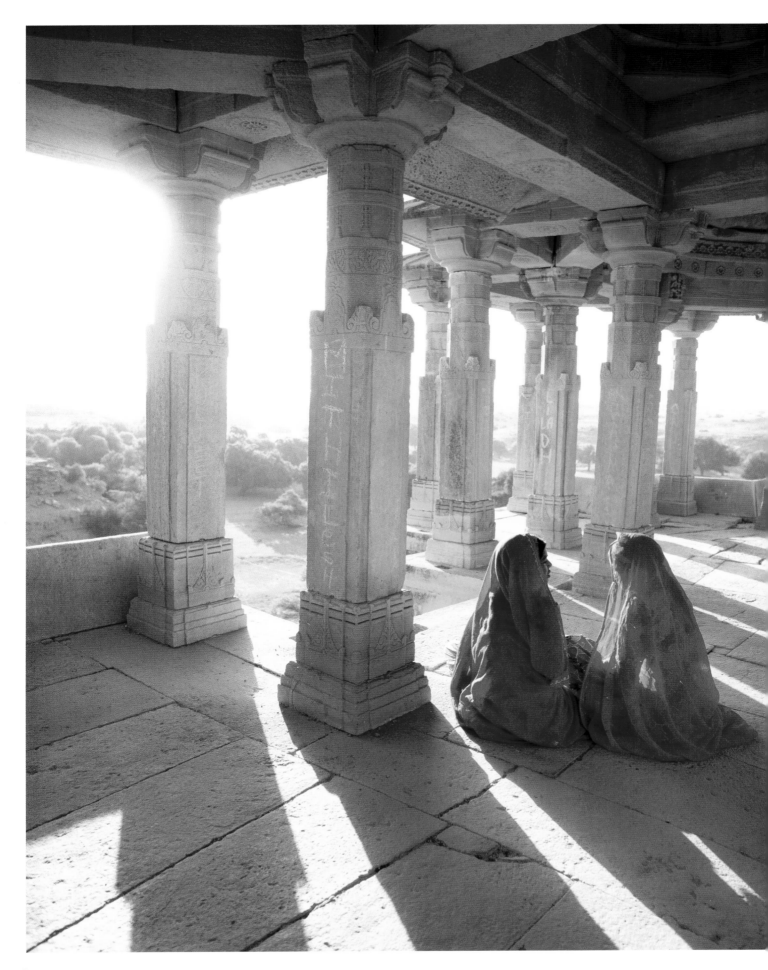

[opposite page]

These two young women were sitting in the tombs built for the concubines of an Indian maharaja in Jaiselmer. The morning sun backlighting the scene created strong, graphic shadows. It was a classic travel shot. I exposed for the foreground architecture and the models, knowing the distant countryside would be lost to overexposure. Using the Sekonic L-508, I took a reading on the shadowed side of the column to the left of the women.

tech data: Mamiya RZ 67 II, 50mm wide-angle lens, 1/60, f/4.5, Fujichrome Velvia, tripod.

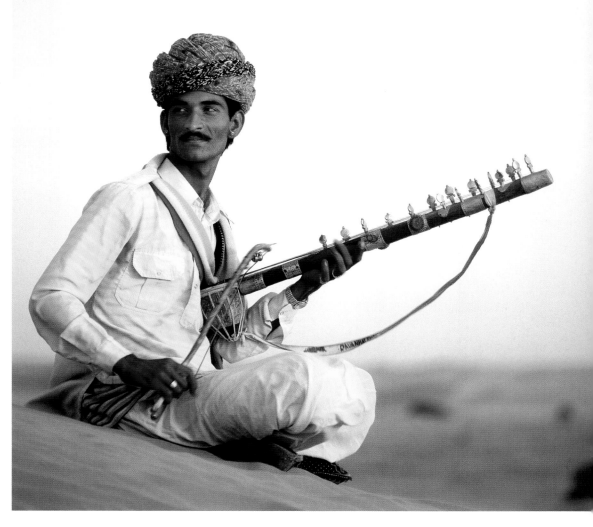

This musician playing on the sands of the Thar Desert in the state of Rajasthan, India, is lit from a weak setting sun to the right of the camera. Although this shot is not backlit, I included it because TTL meters also are affected by a predominately white sky. To circumvent the difficulty, take a TTL reading with the camera pointed downward to exclude the sky from the viewfinder, then use the exposure lock button as you recompose and make the shot. Or you could use a handheld incident meter as I did to determine the correct reading.

tech data: Mamiya RZ 67 II, 250mm telephoto, 1/60, f/5.6, Fujichrome Velvia, tripod.

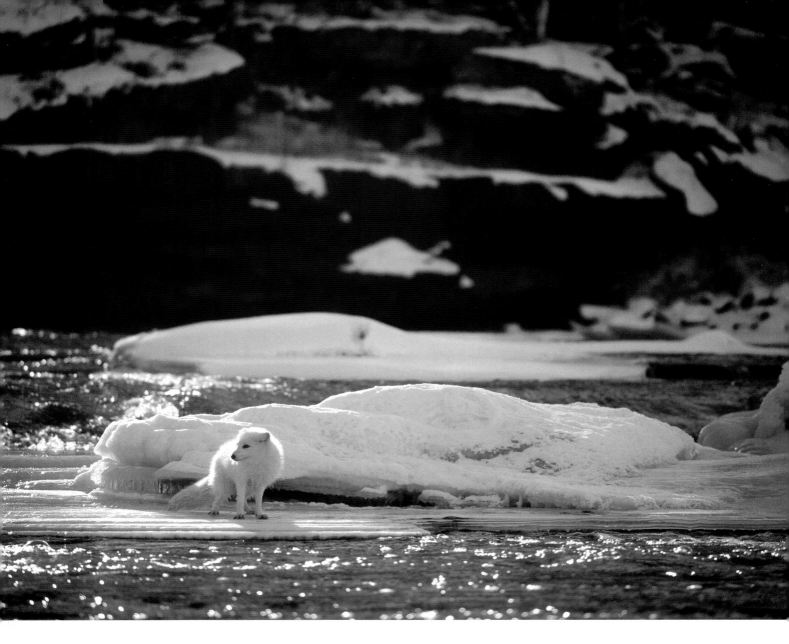

Backlighting that creates a fringe or halo of light around a subject is always a challenge. In this contrasty scene, where there is little besides dark rocks and icy snow, I had few choices as to where I could take a reading. In the end, I identified two places: the small middle-toned patch of grass and snow above the Arctic fox's head and the butterscotch-colored ice on the far right. I used the butterscotch ice to take a reflected reading, and this gave me a correct exposure.

Could I have gotten the proper reading with a TTL meter? Not without compensation. I shot two camera systems on this trip. In addition to my Mamiya RZ, I tested a new Mamiya 645 autofocus on this shoot and used its sophisticated built-in meter. Without compensation, the meter consistently underexposed the images. I had to compensate by 2/3 and sometimes one full f/stop to accommodate the snow and the glare on the water. This is typical of all TTL meters, whether you are using the 35mm or 645 format.

tech data: Mamiya RZ 67 II, 350mm APO telephoto, 1/125, f/5.6, Fujichrome Provia 100F, tripod.

In analyzing the exposure for this shot, my educated guess is that a TTL, without compensation, would underexpose the face of the wolf just enough to make the shot unusable. If you habitually use the TTL meter in your camera, you'd want to use the compensation dial by overexposing one half to one full f/stop (or dialing +1/2 or +1). The question, of course, is exactly how much to open up the lens aperture. By the time you take a second frame, the wolf might be gone.

Instead, I simply took a quick reading with my handheld incident meter with the hemispherical white plastic pointing toward the lens. This gave me an exposure value whereby the side of the wolf facing me would be correctly exposed. I then closed down from this 1/2 f/stop to prevent overexposing the highlights. As long as the wolf remained between the sun and me, I didn't have to change my exposure settings.

tech data: Mamiya RZ 67 II, 500mm APO telephoto lens, 1/250, f/6, Fujichrome Provia 100, tripod.

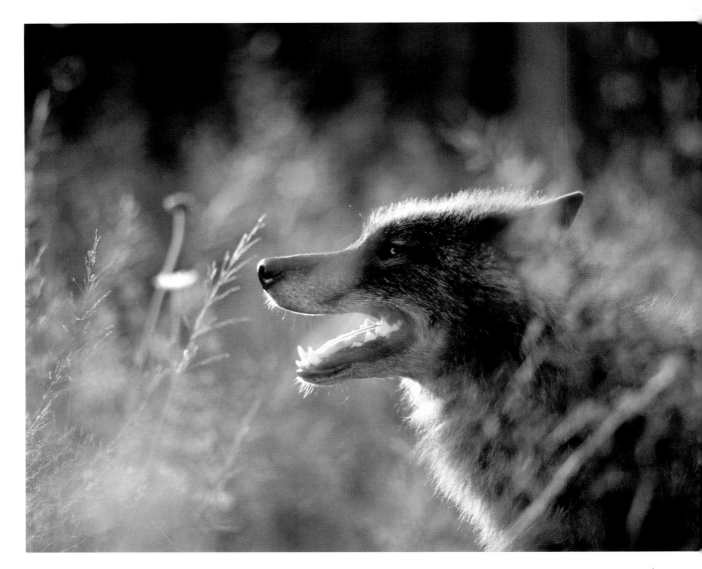

exposure problems
with flash

> > >

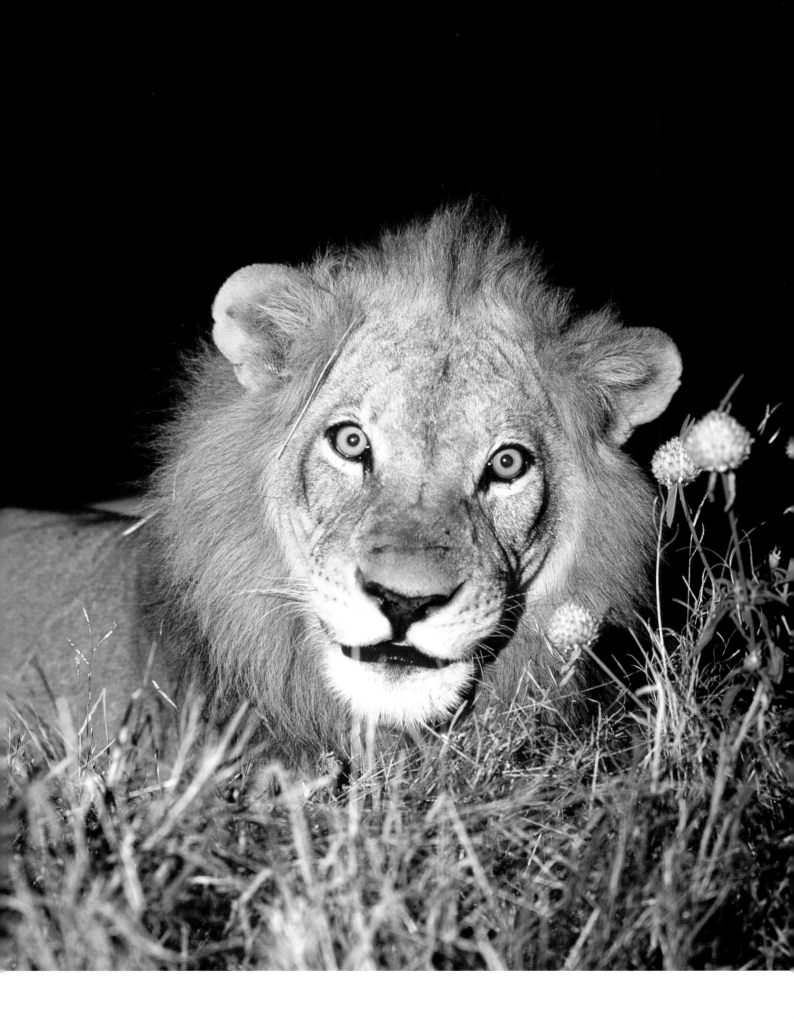

exposure problems [with flash]

electronic automation has made flash and fill flash very easy. No more calculations, no more guessing. Your flash pictures come out perfectly every time. Right? Maybe not.

Sophisticated electronics have made photography with portable flash much easier, just as they have with automatic metering. But like auto metering, automatic flash isn't foolproof. If you defer all the decision making to electronics, you'll be disappointed too often because you won't expect poor exposures and won't understand what went wrong. Let's examine some of the problems associated with automatic flash.

Problem #1: The automatic exposure mechanism in the flash works on the principle that the light emitted from the unit bounces off the subject and reflects back into a sensor. That sensor may be in the flash itself, or it may be in your camera. In either case, the light must bounce back from the subject and affect those sensitive electronics.

If the subject you're shooting is middle toned, the system works well. However, if it is very dark (like a black marine iguana on hardened lava) or very light (a bride leaning against a white wall), you will have the same problem you get with other automatic meters. The auto sensor "thinks" the black subject should be medium gray; the result is overexposure. Similarly, it wants to make the bride medium gray and consequently underexposes the portrait.

Problem #2: The flash can only produce a correct exposure for a particular distance from the subject to the flash. If your subject is ten feet away and is middle toned, it will be properly exposed, but anything in front of it will be overexposed, and the elements behind it will be underexposed.

Let's say you are shooting a group of children at a birthday party. They sit at a long table as you stand at one end to take the picture. If the birthday child is at the center of the table with the cake, and this is the subject the flash exposes for, the kids near you will be too light, and those at the other end will be underexposed.

Another issue is this: The foreground elements on the table might receive enough light that the automatic light sensor treats these as the subject. In this case, the kids near the camera are exposed well, but the birthday boy or girl is too dark, and the children at the far end of the table are considerably underexposed.

Problem #3: Automatic flash exposures are rarely accurate when the subject is only inches away. In other words, in the macro mode you usually can't use auto flash without off-the-film-plane metering.

Problem #4: If you are shooting through glass or into any reflective surface, make sure the light from the flash doesn't reflect back into the camera lens and/or the light sensor. Not only will it degrade the photo, but the exposure will be off as well.

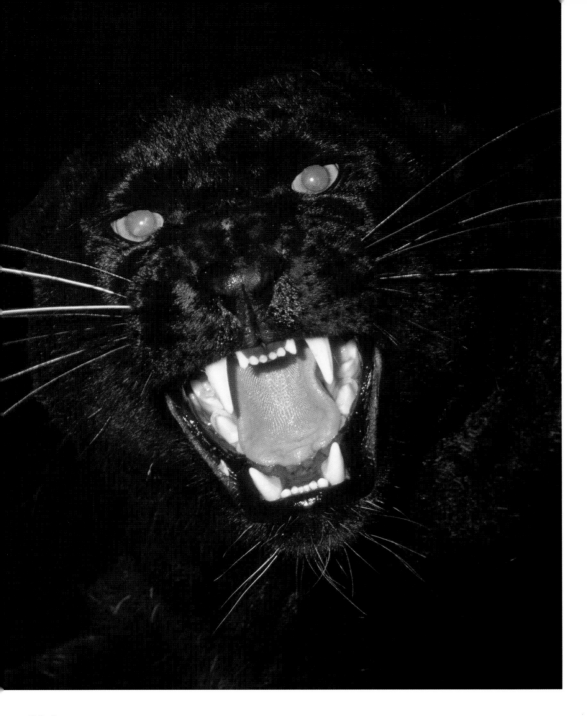

This image of a black leopard was taken in captivity, but it was no easy feat. The cat was uncontrollable with strangers, and it spooked at my presence. The aggressive snarl was not the result of a trained command. This cat wanted to kill me.

An on-camera flash, no matter how sophisticated and expensive, will overexpose this shot if the automatic exposure mode is used. The black hair will absorb so much light that very little will be reflected back into the light sensor. The automatic exposure system tries to make the black cat middle gray (which is how the flash is programmed, just like all light meters), hence overexposing the final picture.

Before the leopard was brought into the enclosure, I had an assistant hold my Sekonic L-508 light meter (which is also a flash meter) in the spot where the cat would be positioned. I tripped the flash and got a reading of f/16 (with the meter held facing the lens). I opened the aperture 1/2 f/stop because I feared losing detail in the black hair. The result is exactly what I wanted. I had purposely placed the flash close to my lens to get the reflection in the eyes. In most mammals, the retinal reflection is green. In humans, it's red ("red eye").

tech data: Mamiya RZ 67 II, 250mm telephoto lens, 1/125, f/11–f/16, Metz 60 CT-1 flash and battery pack, Fujichrome Provia 100F, tripod.

There are many traditional bridal costumes on the island of Java in Indonesia. The young girl pictured here is wearing one of them. The hand-carved wooden background had a varnish on it, and I knew if the flash were fired from the camera position it would reflect in the shiny wood surface.

Unfortunately, I didn't have a PC cord long enough to connect the flash with the camera if the flash unit was moved more than a few inches from the shooting position. The room in which I was shooting was quite dim, so I asked an assistant to hold the flash off to one side of the model. I used a half-second exposure and asked the assistant to trigger the flash as soon as he heard the shutter fire. It worked. The ambient light did not affect the shot.

TECH DATA: Mamiya RZ 67 II, 250mm telephoto lens, 1/2, f/11, Fujichrome Velvia, tripod.

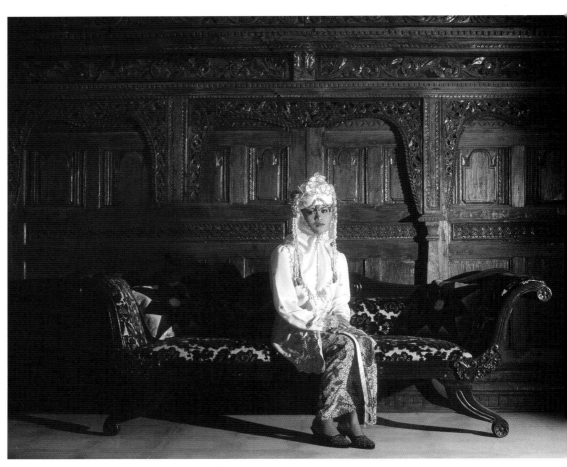

Fill flash is versatile: Sometimes it's subtle fill light for an otherwise dark subject, other times a more dramatic effect. In this shot of a young Balinese dancer in Indonesia, I used the daylight-balanced flash as a contrast against the island sunset. Most modern flash units have an automatic exposure capability whereby both the ambient light and the flash are balanced.

To calculate the exposure the old-fashioned way, first determine the exposure for the background. Then set the flash output such that the required f/stop coincides with the aperture used for the background. In this shot, the background exposure was 1/60 at f/5.6. I used an automatic exposure mode on the flash unit for f/5.6, and the picture was perfectly balanced. The ambient light on the girl wasn't sufficient to influence the exposure.

tech data: Mamiya RZ 67 II, 65mm wide-angle lens, 1/60, f/5.6, Metz 45 flash, Fujichrome Velvia, tripod.

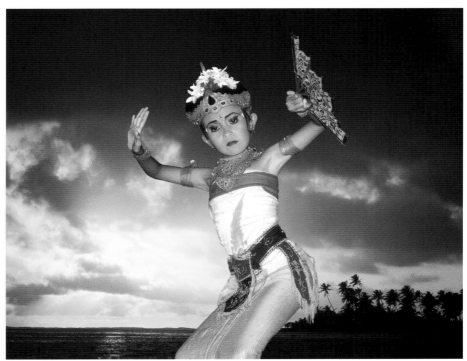

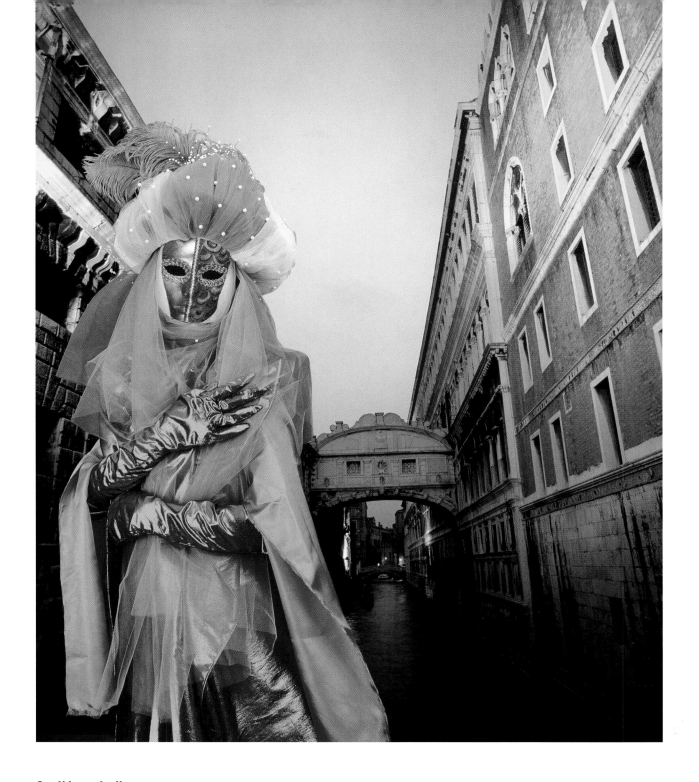

For this portrait of carnival in Venice, I used fill flash at dusk. This was a little trickier than the Balinese dancer because the shutter had to remain open longer to expose the background correctly, and this meant that the model had to remain perfectly still. The fill flash mode on your flash will probably calculate this correctly. I say probably because dusk and twilight can fool meters and light sensors. It wasn't that dark here; perhaps the sophisticated automation in your camera and/or flash would render this shot correctly.

I calculated the exposure with my brain. The exposure on the background was one second at f/8. I set my flash on automatic and used f/8 as my aperture. The buildings were far enough away that they weren't affected by the flash. The model leaned against a low cement wall to brace herself for the long exposure.

tech data: Mamiya RZ 67, 50mm wide-angle lens, Metz 45 flash, 1 second, f/8, Fujichrome Velvia, tripod.

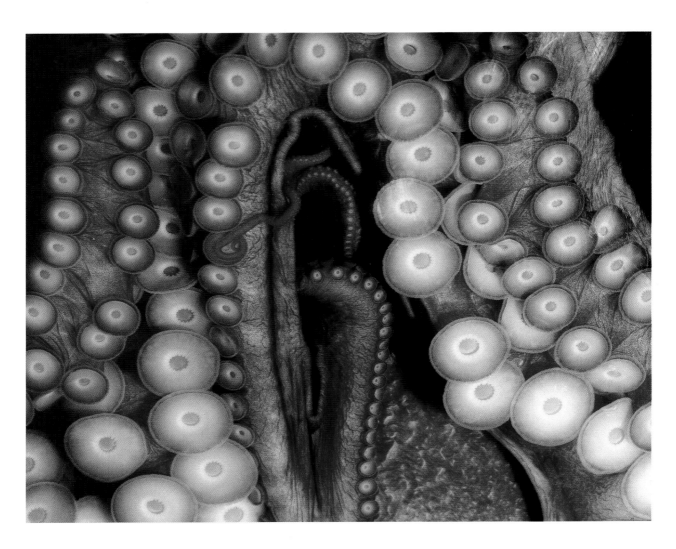

I photographed this octopus in an aquarium. I used a lens hood with the lens placed up against the glass as a guarantee to eliminate any reflection. I took the flash off the camera and held it to the side as a further guarantee there would be no distracting reflections. With off-the-film-plane automatic exposure, the exposure should be accurate even if the flash is providing sidelighting.

The Mamiya RZ doesn't offer this type of flash metering, so I use the handheld Sekonic L-508 for all my flash exposures.

tech data: Mamiya RZ 67 II, 110mm normal lens, 1/125, f/16, Metz 45 flash, Fujichrome Velvia, handheld.

This chameleon was positioned in the shade of a tree, and the background was lighter than the reptile. I used fill flash to balance the two. However, I specifically wanted shallow depth of field to soften the background. I felt that sharply defined foliage would distract from the subject. I used a telephoto and the largest aperture on the lens to achieve this effect. However, I underexposed the exposure from the flash by 1/2 f/stop so the chameleon wouldn't be inappropriately lit. Note that with two previous examples—the Balinese dancer and carnival in Venice—I didn't reduce the flash exposure because there was very little ambient light on these two subjects.

tech data: Mamiya RZ 67 II, 350mm APO telephoto, 1/60, f/5.6, Metz 45 flash, Fujichrome Velvia, tripod.

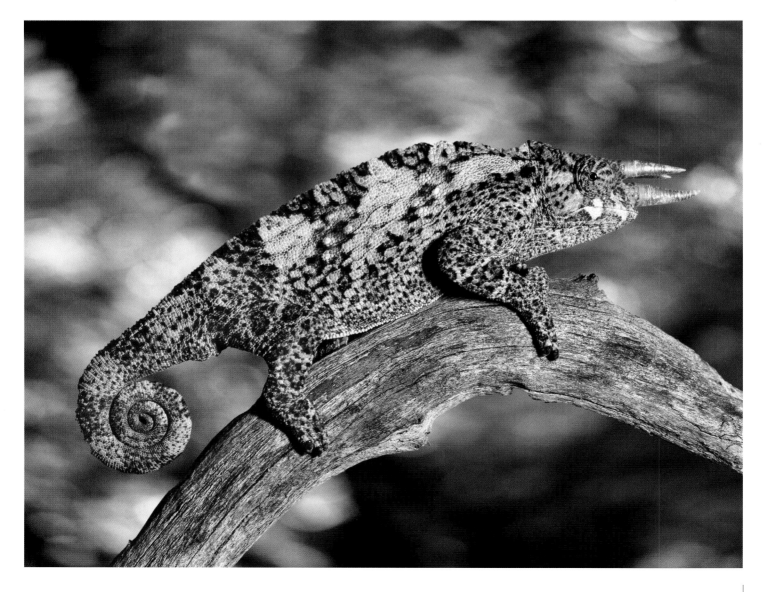

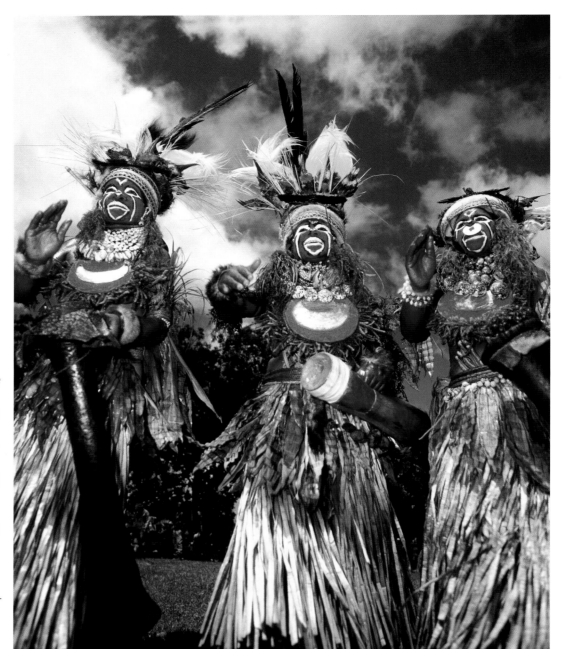

This image was taken in Papua New Guinea during the annual Sing Sing, when many tribes get together to sing and dance. On an overcast day, or in the early morning, the light is ideal. On this day, however, a high overhead sun cast harsh shadows on the dancers, which made good travel photography impossible without fill flash.

I sat on the ground and composed this shot with a wide-angle lens as the young girls danced around me. The daylight reading with ISO 100 was 1/250 at f/8 plus 2/3. I set my flash to correctly expose the faces at f/11, underexposing by only 1/3 f/stop.

tech data: Mamiya RZ 67 II, 50mm wide-angle lens, 1/250, f/11, Metz 45 flash, Fujichrome Provia 100, handheld.

[opposite page]

When you use flash with a subject that is relatively far from a dark background, that background usually goes black. I did not photograph these young girls in India at night, but it appears that way because the light from the flash didn't illuminate the elements that were about thirty feet behind them. I used the automatic exposure mode on my flash because the two dancers were middle toned. This only works, though, if the subject is prominent enough to bounce the flash's light back into the sensor to determine the exposure. Had I composed this picture with only the faces in view and lots of room at the top of the frame (which I admit would have been a foolish composition, but I'm making a point), the flash would have tried to properly expose the background, thus overexposing the two dancers.

tech data: Mamiya RZ 67 II, 1/125, f/11, Metz 45 flash, Tiffen diffusion filter, Fujichrome Velvia, tripod.

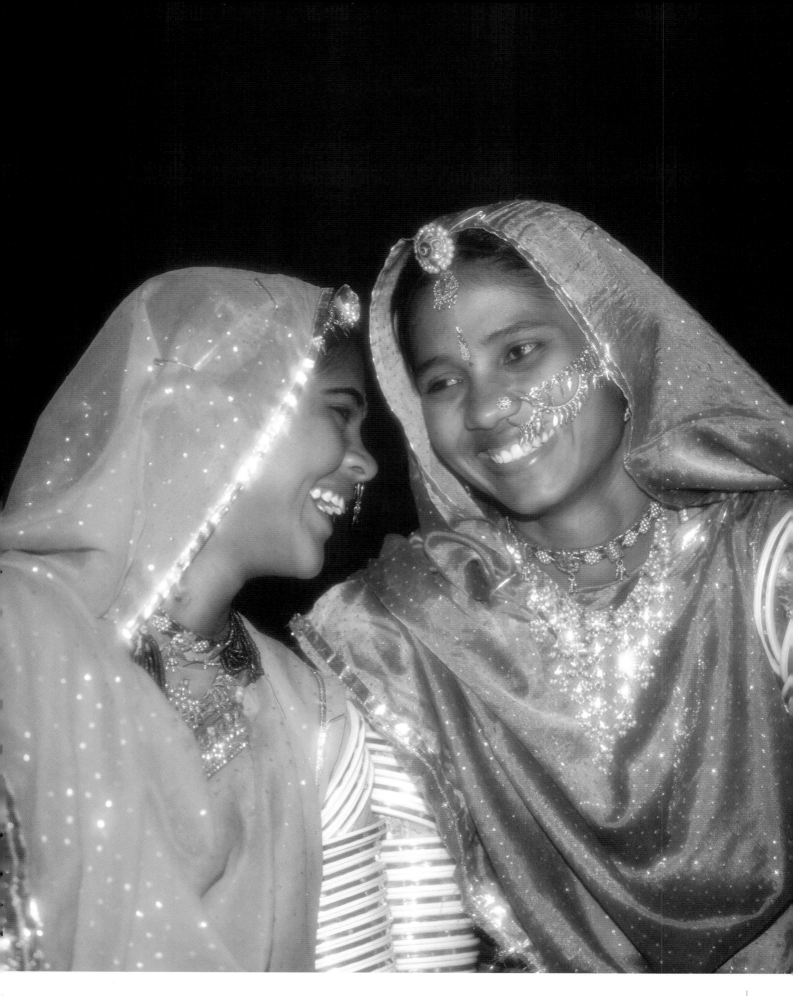

I took the flash off my camera to make this shot of a temple relief in Angkor Wat, Cambodia. The extreme sidelighting came by placing the flash head against the stonework. I did this to allow the formation of shadows and highlights, which give the picture its depth. Taken with the flash on the camera, the picture would seem flat and lifeless. I used a warming filter over the camera lens.

A 35mm camera with off-the-film-plane metering would read the light correctly. Instead, I used an incident meter held against the wall, facing the camera. It's important that the light hit the meter's hemispherical dome just as it strikes the subject—in this case, from the side. I didn't have a connecting PC cord, and since it was quite dark in the corridor where I was shooting, I opened the shutter for a half-second as my taxi driver tripped the flash.

tech data: Mamiya RZ 67 II, 110mm normal lens, 1/2, f/22, Metz 45 flash, Fujichrome Velvia, 80C warming filter, tripod.

[opposite page]

To create the illusion of movement, I used a long shutter speed and a flash to capture these male dancers from the Huli tribe in Papua New Guinea. The quarter-second exposure blurred the men while the flash superimposed a sharp image of the group over the blurred one. This technique is almost like a double exposure: a sharp image combined with a blur.

The afternoon was deeply over-cast. This allowed for the extended shutter speed. I first took an ambient daylight reading, 1/30 at f/5.6. I extrapolated from this to get 1/4 at f/16 and then set my flash to underexpose by 1/2 f/stop and made the shot.

tech data: Mamiya RZ 67 II, 110mm normal lens, 1/4, f/16, Metz 45 flash, Fujichrome Provia 100, tripod.

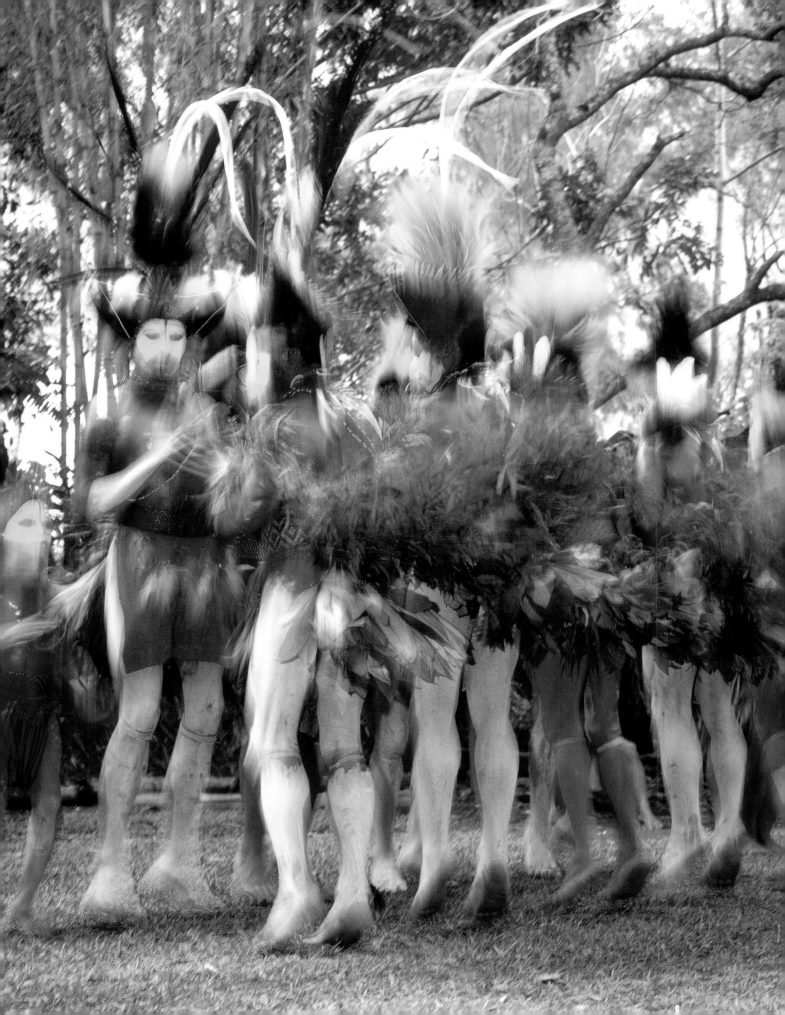

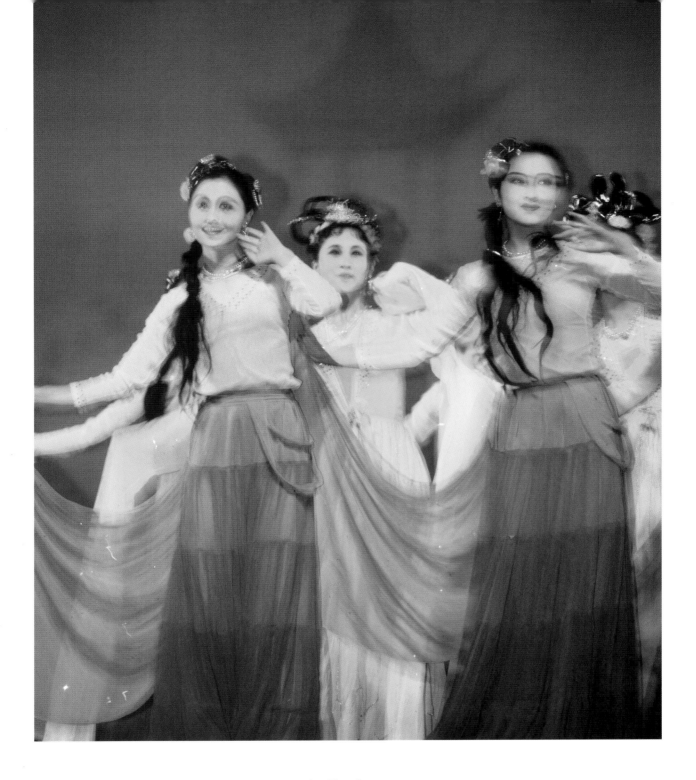

I achieved an effect similar to that on page 101 with these dancers many years ago on a stage in Beijing, China. The amount of blur depended on the shutter speed and amount of movement in the subjects. If you want a very abstract image, use a longer exposure. Here, I took a reading with a one-degree spot meter from the audience; I metered the skin tones of the performers. Then I underexposed the flash by 1/2 f/stop and made the shot. Note the combination of tungsten stage lighting and the cooler light from the flash unit.

tech data: Mamiya RZ 67, 180mm telephoto lens, 1/4, f/4.5, Vivitar 283, Ektachrome 64, handheld.

This picture from the early '80s remains one of the more interesting images I've made with flash. Actually, the flash units that exposed this picture weren't mine. I was high in the grandstand, too far away for a portable flash to be effective. The flash units belonged to the photographers positioned right next to the racetrack. As they took their pictures, my open shutter recorded their burst of light.

Here's how I calculated the exposure: The formula to determine aperture is "Guide number = lens aperture x distance." Or, "Lens aperture = guide number ÷ distance." I assumed the guide number of the flash units being used was 120 at ISO 400, an educated guess. I estimated the distance from the photographers to the funny cars was about 15 feet. Plugging the numbers in gave me $120 \div 15 = 8$. My aperture, then, was f/8. I used a one-second exposure and panned with the cars to add horizontal blur to the image.

TECH DATA: Mamiya RZ 67, 500mm telephoto lens, 1 second, f/8, Ektachrome 400, tripod.

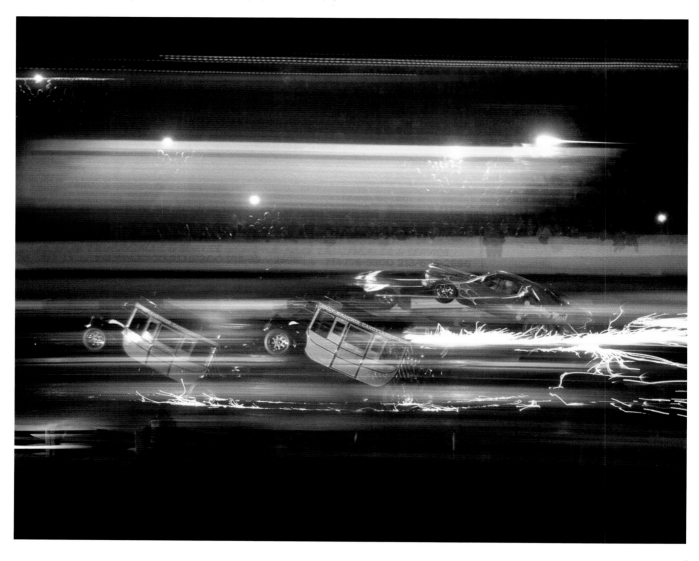

> > >

chapter seven

exposing for
macro photography

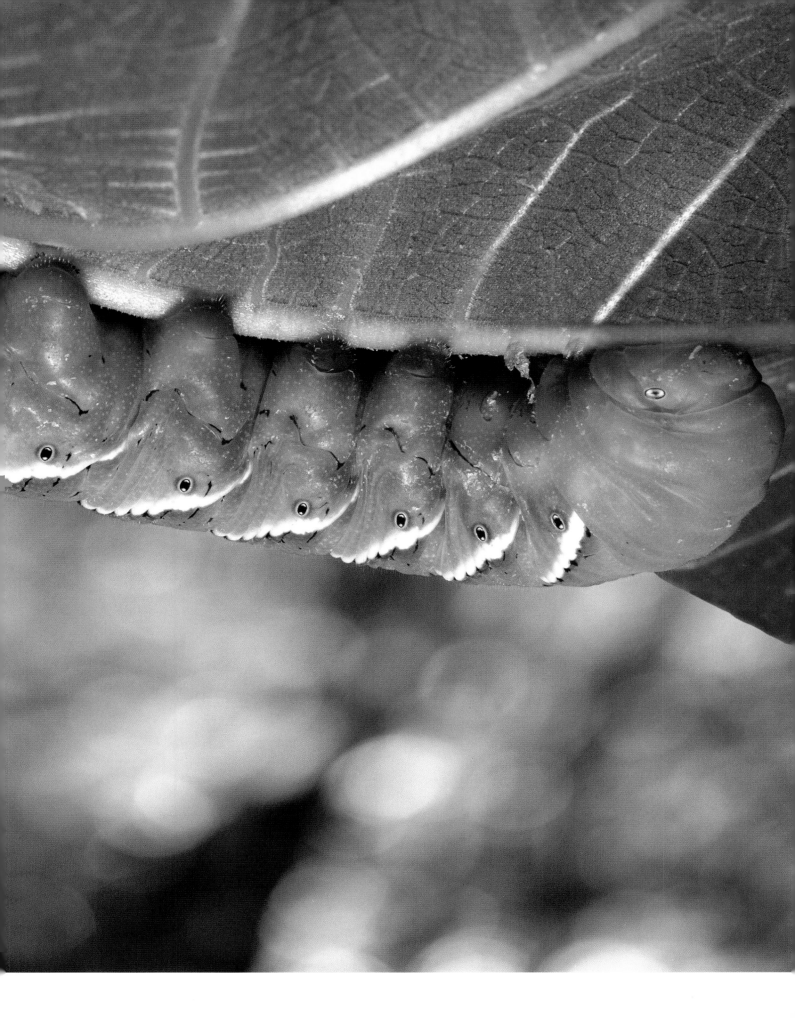

exposing for [macro photography]

in order to focus on an object very close to the camera, you must use either a macro lens or another piece of gear in conjunction with a fixed focal length lens. The easiest and least expensive way to shoot closeups is with a diopter. This is simply a filterlike piece of glass that screws on the front of a normal or medium telephoto lens. My choice is the Canon 500D, a two-element diopter that produces a sharp image from edge to edge. This does not affect exposure; it requires no compensation for light loss. Diopters come in many sizes to fit various lenses.

Extension tubes and bellows are another way to focus closely on small objects. These do, however, cause light loss. Any time the lens is moved away from the film plane (because the tubes or bellows attach between the lens and the body, moving the lens further from the film), there is a significant reduction in light entering the camera.

You can calculate this reduction with a simple formula: $(M + 1)^2$

M is the magnification, which is determined by dividing the lens-to-film distance by the lens-to-subject distance (the point in the lens that is used to measure these is the position of the diaphragm).

If, for example, the lens-to-film distance is 10 inches, and the lens-to-subject distance is 22 inches, the magnification equals 10 divided by 22 (.45). Plugging this into the formula, we have:

$$(.45 + 1)^2 = (1.45 \times 1.45) = 2.1$$

This means a two times increase in light is needed, which translates to opening the lens aperture one f/stop. Many photographers like this method of macro work because they don't introduce glass into the optical system. Extension tubes and bellows are hollow. Only the expensive lens elements in the prime lens are used to render the image on film.

TTL meters automatically calculate the light reduction that this extension causes. For middle-toned subjects, these meters are quite accurate. If you don't want to depend on automation to determine macro exposures, however, or if there are other factors involved, such as a totally manual camera, illumination from flash or contrast problems, consider calculating the exposure with information from the following captions.

This shot of a prickly pear cactus in Anza-Borrego Desert State Park, California, is the kind of composition that a TTL meter can read with accuracy, no matter how much light loss is caused by extension tubes, bellows or a macro lens extended to its full length. The tones are middle gray. However, I used a #1 extension tube on the Mamiya RZ and calculated the exposure mentally. All tubes come with exposure data for use on normal lenses. The tube I used, for example, requires a 2/3 f/stop compensation. If the reading with a handheld meter were 1/8 at f/32 plus 1/3, the final shot would be taken at 1/8 at f/22 plus 2/3.

Note that if the background foliage were closer to the cactus, it would have been defined by the extensive depth of field and would therefore have been intrusive. In other words, it would have been too busy. The fact that it remained diffused due to its distance saved the shot.

tech data: Mamiya RZ 67 II, 110mm normal lens, #1 extension tube, 1/8, f/22 plus 2/3, Fujichrome Velvia, tripod.

The Canon 500D diopter reduces the working distance from the lens to the subject to only inches. Extension tubes, when used with telephoto lenses, permit you to shoot much further from the subject yet still fill the frame with a small subject. The only time I've been literally terrified of a subject was when I photographed this green mamba, an ultra-deadly venomous snake. A bite from this slender snake is an immediate death sentence.

To maintain my distance, I used an extension tube on a 350mm APO telephoto. I determined my exposure calculation before I approached the snake so all my attention could be on shooting and getting out of there.

tech data: Mamiya RZ 67 II, 350mm APO telephoto lens, #1 extension tube, 1/125, f/5.6–f/8, Metz 45 flash, Fujichrome Provia 100F, tripod.

Skittish subjects like this rice paper butterfly in the Philippines can only be approached if you move very slowly. As soon as their compound eyes detect movement, they're gone. Using extension tubes on a telephoto allows you to position the camera at a distance that is less likely to disturb them. I determined the exposure with the Sekonic L-508 on incident mode and then calculated for the light loss (using the formula on page 106). I used the larger Mamiya extension tube, which reduces the exposure by one and a third f/stops.

tech data: Mamiya RZ 67 II, 250mm telephoto, #1 extension tube, 1/15, f/8, Fujichrome Provia 100F, tripod.

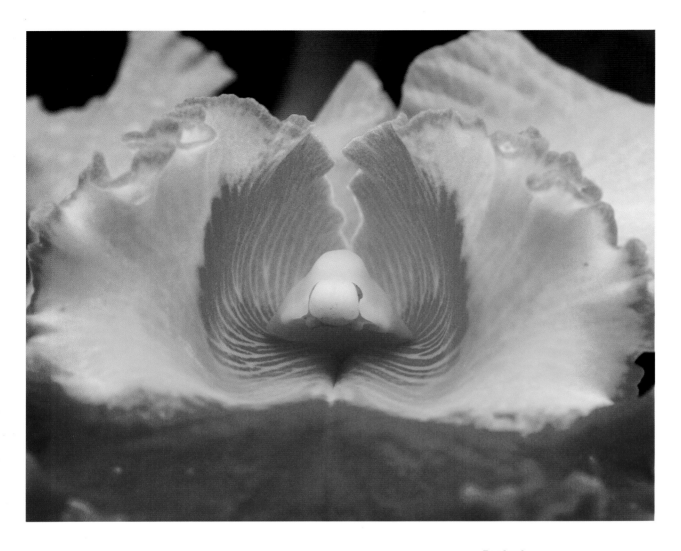

To shoot the inside of this orchid, I used a 500D plus two extension tubes and a bellows extension. The light loss was three full f/stops. This meant, in turn, that the shutter had to be very long in order for me to maintain as much depth of field as possible. The handheld incident meter gave me a reading of eight seconds at f/128. Due to the light loss, I used an aperture of f/45 (f/128 to f/90 to f/64 to f/45). It was absolutely critical that wind not be a factor.

tech data: Mamiya RZ 67 II, 250mm telephoto, 500D diopter, #1 and #2 extension tube, 8 seconds, f/45, Fujichrome Velvia, tripod.

A handheld incident meter interprets the light as you see it. Due to the dark color of this ornate horned frog, I tweaked the reading by increasing my exposure by 1/2 f/stop from what the meter indicated. In addition, the #1 extension tube for the Mamiya RZ system required a 2/3 f/stop compensation. Because I used such a slow shutter speed, I took several frames to make sure one of them was sharp.

tech data: Mamiya RZ 67, 250mm telephoto lens, #1 extension tube, 1/2, f/16, Fujichrome Provia 100F, tripod.

When using flash in macro work, it's important to angle the beam of light correctly. If your working distance is very close and the flash is sitting on the camera's hotshoe, the angle of light may be too high—you may be illuminating the background. In this case, it's best to use a telephoto macro lens where you are shooting from a few feet away. Or, you can use extension tubes in conjunction with a telephoto lens as I did here to capture this downy great horned owl.

tech data: Mamiya RZ 67, 250mm telephoto, #1 extension tube, 1/125, f/11, Fujichrome 50D, tripod.

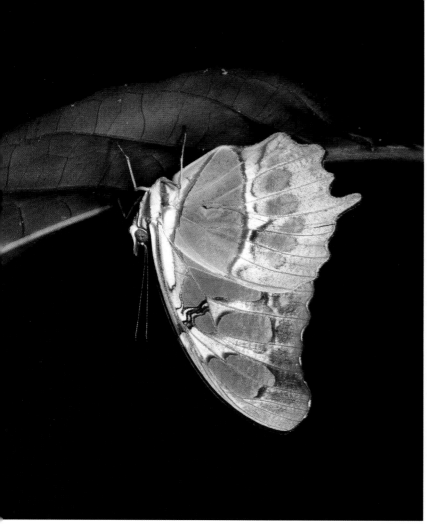

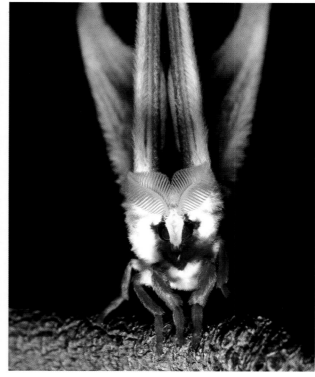

If the background behind your subject is several feet away and you are properly exposing a macro subject, the background will go black when using a flash. This is appropriate for a moth, such as this newly emerged luna moth (right). These insects are nocturnal. However, when shooting butterflies, a black background isn't right. Butterflies fly only during the day. The malachite butterfly I photographed hiding under a leaf during a rainstorm in Florida is a favorite shot of mine, but the trees in the forest were too far away to see with the flash. The black background always disturbed me.

The best solution for avoiding this is to place a mounted photographic print of out-of-focus foliage behind the subject. Not only will the background remain nicely diffused, but it won't be dark if you use a flash. Just be careful the subject does not cast a shadow on the photographic print.

tech data: a. butterfly: Mamiya RZ 67, 250mm telephoto, #1 extension tube, 1/60, f/11, Fujichrome 50D, Metz 45 flash, tripod.
b. moth: Mamiya RZ 67, 127mm normal lens, #1 and #2 extension tubes, 1/125, f/22, Metz 45 flash, Fujichrome 50D, tripod.

I photographed this walking stick with a flash, but I used a 13 x 19 inch print of out-of-focus foliage behind it to prevent the background from going black. I made the print with my desktop printer (an Epson 1270) and mounted it on foam core. I elected to use flash because the additional light allowed me to freeze any movement and use a small aperture for complete depth of field on the insect. Because I used the Canon 500D diopter, no compensation for light loss was necessary.

tech data: Mamiya RZ 67 II, 250mm telephoto, Canon 500D diopter, Zap 1000 strobe and white umbrella, 1/125, f/22, Fujichrome Velvia, tripod.

This eyelash viper is another venomous snake that requires a safe working distance. Snakes can't strike more than the length of their body, and since this was a baby, I was only about two and a half feet away. The viper was close to the ground, and many photographers would simply shoot downward from a standing position. However, the face of the palm frond on which it was intertwined was perpendicular to the ground. This meant that from a standing position, with the camera pointing downward, the film plane would not be parallel to the palm. The shallow depth of field associated with macro photography can be mitigated somewhat in this situation by shooting from a low position, where the film plane is parallel to the subject. This is an important strategy—especially in medium format, where depth of field is even less than in 35mm.

tech data: Mamiya RZ 67, 250mm telephoto, #2 extension tube, 1/8, f/16, Fujichrome Provia 100F, tripod.

As I composed this shot of a wild rose in Glacier National Park in Montana, I cast a light shadow on the flower. It was subtle but nevertheless had to be considered. If I had taken the light reading with a handheld meter, I would have had to take the photograph under the same lighting conditions as the meter reading. Because I metered the flower while in my shadow, that's how the picture had to be captured on film. The bluish tone in the image comes from the fact that the rose was in the deep shade of a large tree.

tech data: Mamiya RZ 67 II, 110mm normal lens, Canon 500D diopter, 1/2, f/22, Fujichrome Provia 100F, tripod.

This picture of a gray lourie in Botswana is not a macro shot, yet I used an extension tube. Extension tubes can be used on long lenses to reduce their minimum focusing distance. I took this shot with a 500mm APO telephoto, but I was only about five or six feet away (I baited the wild bird with food). The RZ 500mm APO will not focus this close, but with the addition of the #1 extension tube it did.

tech data: Mamiya RZ 67 II, 500mm APO telephoto, #1 extension tube, 1/250, f/6, Fujichrome Provia 100F, tripod.

Here is another example of the importance of maintaining parallelism between the film plane and the subject. This close-up of an old door in Bali is only a worthwhile image if all the rich detail is sharp. Sometimes, to make sure the back of the camera is parallel with a flat subject, I will take a step or two to the side of the camera setup and look at it from that angle. You can immediately see if any adjustments must be made.

I used a handheld meter on incident mode to read the light here. Sometimes I don't trust a reflected meter reading if the sun's angle is such that it might create a sheen or glare on the subject. This glare would never fool an incident meter. I held the meter so the white hemispherical dome was pointed at the camera lens.

tech data: Mamiya RZ 67 II, 350mm APO telephoto, #1 extension tube, 1/8, f/22, Fujichrome Velvia, tripod.

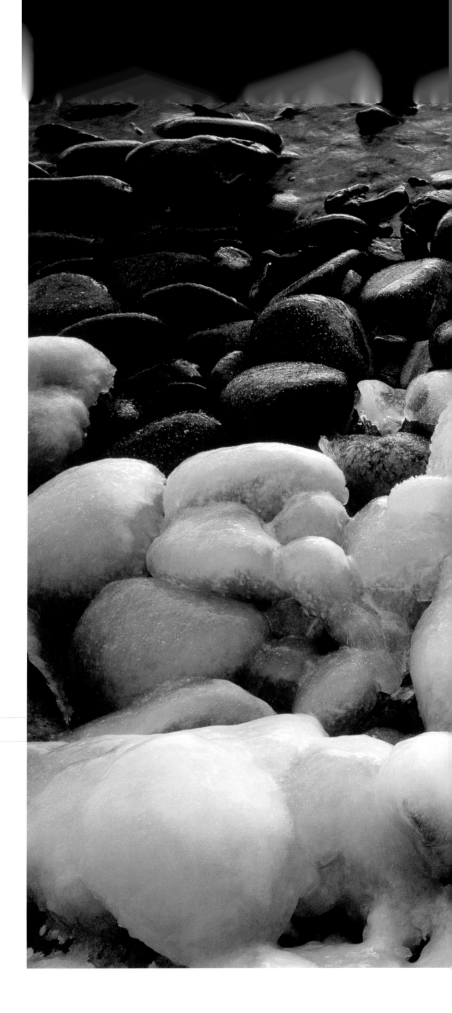

exposing in
extreme contrast

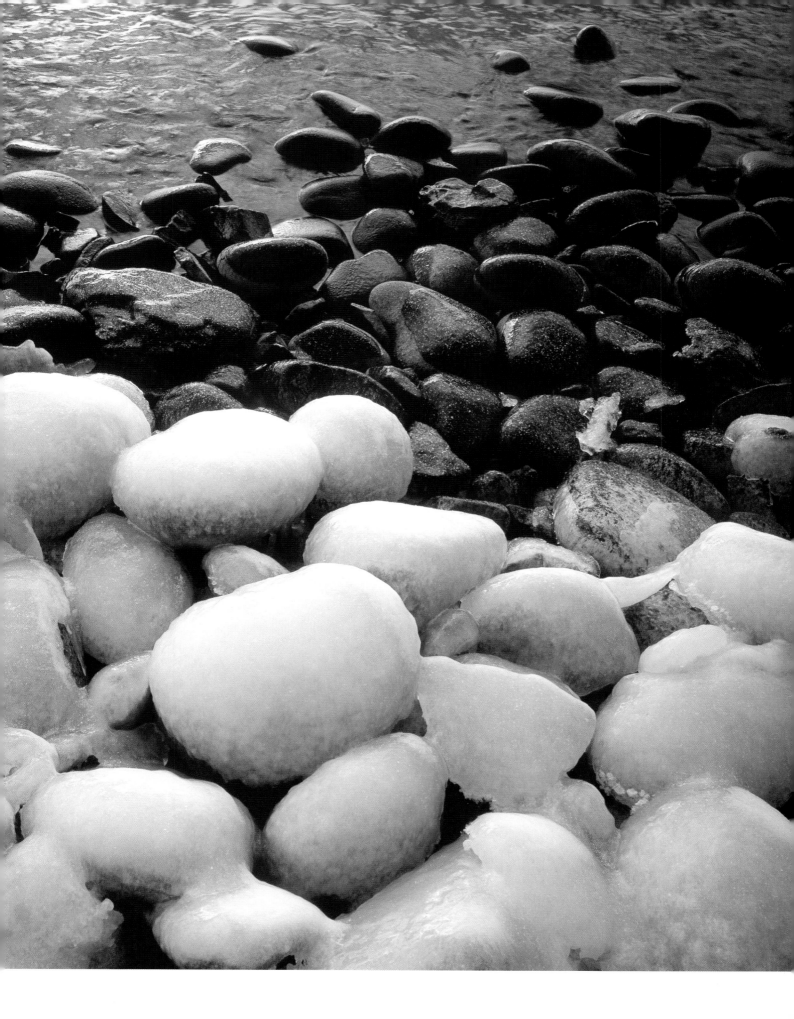

exposing in
[extreme contrast]

brilliant highlights and dark or black shadows in a single photograph present exposure problems. As I've explained in previous chapters, meters try to render both black and white portions of a composition as medium gray. If a majority of the frame is contrasty—that is, consisting of large areas of shadows and highlights—the meter may in fact average them together and come up with the perfect exposure, or it may not. You cannot know for sure. The likelihood that you will be pleased by the automatically determined exposure is not good.

The choice of film can also be a factor in dealing with compositions of extreme contrast. One of my two favorite films, Fujichrome Velvia, is indeed contrasty. Fujichrome Provia 100F and Kodak Ektachrome VS are less contrasty. Depending on the effect I want to achieve, I will select the film that will either exaggerate or minimize the contrast. For example, at sunrise and sunset, when the light of the sun is muted by the atmosphere, Velvia is a wonderful film for landscapes. But if I'm forced to shoot when the sun is high, I will often switch to another film to prevent shad-

ows from going black or highlights from losing detail to overexposure.

But first you must recognize when a contrasty shot might be a problem. The following photographs should help you do that. Then you must find a solution. As with other challenging situations discussed in this book, you have two guaranteed ways of deriving the correct exposure: Find a middle-toned area in the shot and take a reading with a reflected meter (which includes the TTL meter in your camera), or use a handheld incident meter to read the light falling on the scene. In most of the photographs you take, whether indoors or out, in Boston or in Botswana, this works.

The trail to the ancient city of Petra, in Jordan, is in a dark, narrow canyon. When I first glimpsed the two thousand-year-old ruins, the shadowed canyon walls contrasted sharply with the facade of the columned architecture, which was fully illuminated by a bright, overcast sky. The difference between the shadows and highlights was about five f/stops. If I had exposed for the dark canyon walls, the building would be grossly overexposed. If I had exposed for the facade, the canyon would be too dark. If I compromised, the ruins would still be overexposed and the canyon sandstone would be lighter but still in shadow.

I chose to expose for the building and leave the canyon in shadow. An incident meter wouldn't work because the light in the canyon was different from the light on the subject. I switched to the Sekonic L-508's reflected mode and read a middle tone, the lower part of the bottom right column.

tech data: Mamiya RZ 67 II, 250mm telephoto, 1/4, f/32, Fujichrome Velvia, tripod.

Although there are quite a few middle tones in this picture, the bright, early-morning sunlight bouncing off the stone blocks on the corridor floor plus the numerous dark shadows made me hesitant to rely on a TTL meter, even the sophisticated one in the AE prism on the RZ. This kind of exposure situation demanded precision. I walked up to the back of the model, took a reflected reading off her clothing and used that reading for the shot.

TECH DATA: Mamiya RZ 67 II, 250mm telephoto, 1/4, f/22, Fujichrome Velvia, tripod.

Patchy sunlight always presents a tough situation. I usually avoid it at all costs. In this case, the highlight is illuminating the white collar on the cheetah's neck. This increases the contrast with the shadows on the side of the face and in the background.

In taking my light reading, I used a reflected spot meter to read the light on the cheetah's head below and to the right of the ear. He was just sitting there in the tall grass, so I had enough time to analyze the situation. I knew that if I exposed this middle tone correctly, the highlights and shadows would be ren-dered as good as possible. The white hair under the neck is indeed the brightest part of the picture, and it takes attention away from the face, specifically the eyes, where most of a viewer's attention should be. However, if I underexposed the photo to diminish the intrusion of the bright, white color, the animal's face would be underex-posed to a fault. I had no other choice than to do what I did here.

TECH DATA: Mamiya RZ 67 II, 500mm APO telephoto, 1/125, f/6, Fujichrome Provia 100F, camera rested on beanbag in Land Rover.

I was faced with the same situation when I shot this model in Venice, Italy. While in a gondola, we entered a section on a canal between two buildings where the overhead sun created contrasty shadows. Most of the photo session had been in the soft light of shade, but I thought I'd try something different. Rather than the face being light and the body dark, as with the dancer in New Guinea, the black mask was a counterpoint to the lighter costume. Notice, however, how I captured detail in the black portion of the mask. Even a small amount of underexposure would have lost this subtlety. Without bracketing, I used an incident reading with the Sekonic L-508 and got a perfect exposure.

tech data: Mamiya RZ 67 II, 110mm normal lens, 1/125, f/8, Fujichrome Velvia, handheld in boat.

[opposite page]

Another situation I try to avoid is shooting with a high, overhead sun. The shadows under the eyes and harsh contrast created by this angle of light are unflattering. During the annual Sing Sing in Papua New Guinea, I had no choice for much of the day. The tonal values in this shot of a dancer from the Huli tribe were stark: brilliant yellow face paint and a brown body oiled with pig fat. This is the classic example where a TTL meter might not give you a proper reading. Even slight overexposure would wash out the intense yellow color in the face, while a small amount of underexposure would cause a loss of detail in the dark tones.

I read the light with my handheld incident meter. Unaffected by the reflective surface of the subject, incident meters read the light falling on the scene.

tech data: Mamiya RZ 67, 250mm telephoto, 1/250, f/8–f/11, Fujichrome Provia 100, tripod.

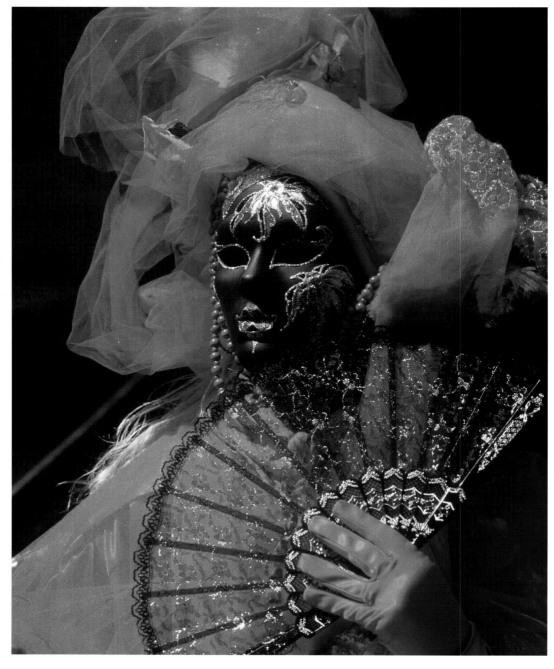

Another circumstance I try to avoid is a dark subject in front of a light background. Sometimes it works, but usually it doesn't. The lighter elements behind the subject usually detract from the important part of the composition, in this case the leopard.

Without your direct intervention, all TTL meters will underexpose this shot. The bright background will cause the meter to reduce the light reaching the film, and the cat will be too dark. Instead, you can point the TTL meter downward and take a reading eliminating most of the sunlit background from the meter's view. Then, with the exposure lock on, recompose and shoot.

tech data: Mamiya RZ 67 II, 350mm APO telephoto, 1/60, f/5.6, Fujichrome Provia 100F, tripod.

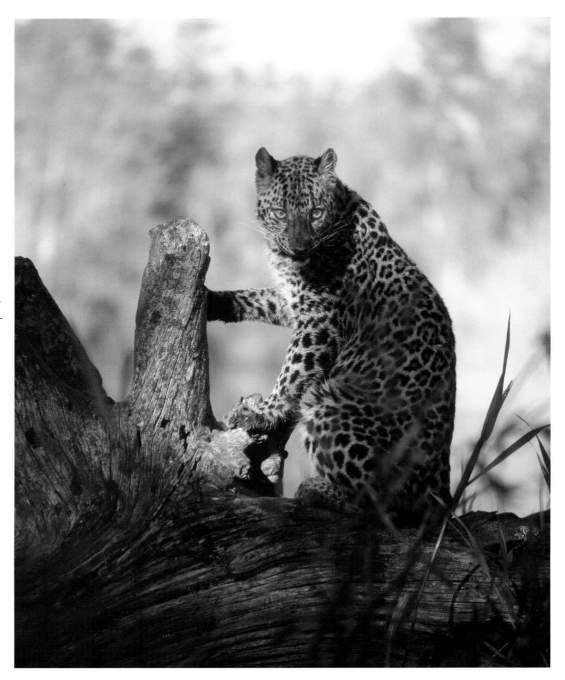

[opposite page]

Mercury vapor lamps at the Temple of Edfu in Egypt account for the green-blue color on the ancient columns. However, the extreme contrast between the shadows and the blown out highlights was caused by the placement of the light fixtures. The stonework close to the lights received much more light than the upper portions of the columns and the ceiling. Daylight filtered in through a large doorway to the left, but this didn't effect the contrast of the dominant artificial lighting.

Had I exposed for the blown out highlights, the rest of the interior would have been dark. I had to sacrifice the detail near the light fixtures in exchange for detail in the rest of the chamber. I selected a medium-toned portion of a column and took a reading with a handheld reflected meter. Had I been carrying neutral density gels, I could have placed them over the light fixtures to balance the illumination between the daylight and artificial light sources.

tech data: Mamiya 7, 43mm wide-angle lens, 1/2, f/22, Fujichrome Velvia, tripod.

A different contrasty situation presented itself in Florence, Italy. In this case, the artificial light was tungsten and it lit murals evenly, but the foreground and the peripheral portions of the chapel were dark. Again using a reflected reading on spot mode, I found a middle-gray area from which to take a reading. I used the upper portion of the mural on the left side of the frame. The detail in the foreground, which I was able to see with my eyes, was largely lost due to the inability of film to handle such a wide exposure range. This is just one of the compromises necessary in photography.

tech data: Mamiya RZ 67 II, 50mm wide-angle lens, 1 second, f/32, Fujichrome Velvia, tripod.

During breeding season at Tower Island in the Galapagos Islands, male frigate birds exhibit a huge, red pouch to attract females. When front lit, the birds' black feathers, although dark, do reflect sunlight. The contrast between the feathers and the red pouch isn't extreme, but the huge pouch cast a shadow on the bird's body, and trying to hold detail in the highlighted beak while retaining detail in the feathers was a challenge. I used the dark area of the pouch as a middle tone and took a reflected reading from that. With a TTL meter, you could simply use spot mode. Lock that exposure in place, and compose and take the shot.

TECH DATA: Mamiya RZ 67 II, 250mm telephoto, 1/250, f/4.5, Fujichrome Provia 100, tripod.

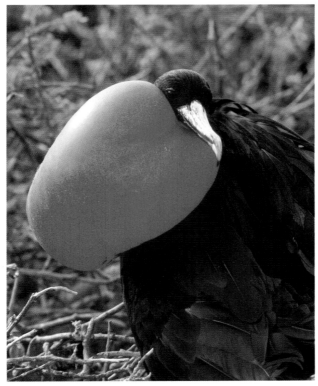

This is one of my favorite pictures I've taken of the slot canyons in Arizona. In order to render the fluid contours of the sandstone properly, I had to completely ignore the brilliant white sky. All TTL meters would underexpose this composition even though the low cloud cover was not as brilliant as direct sunlight. A TTL meter could read the underside of the canyon's overhang, and then, with the exposure lock in place, you could recompose and shoot. Always make sure the meter never sees any portion of the whiteness when it takes the reading. I used a handheld meter on reflected mode to read the light.

tech data: Mamiya RZ 67 II, 50mm wide-angle lens, 1/2, f/32, Fujichrome Velvia, tripod.

> > > chapter nine
impossible
metering situations

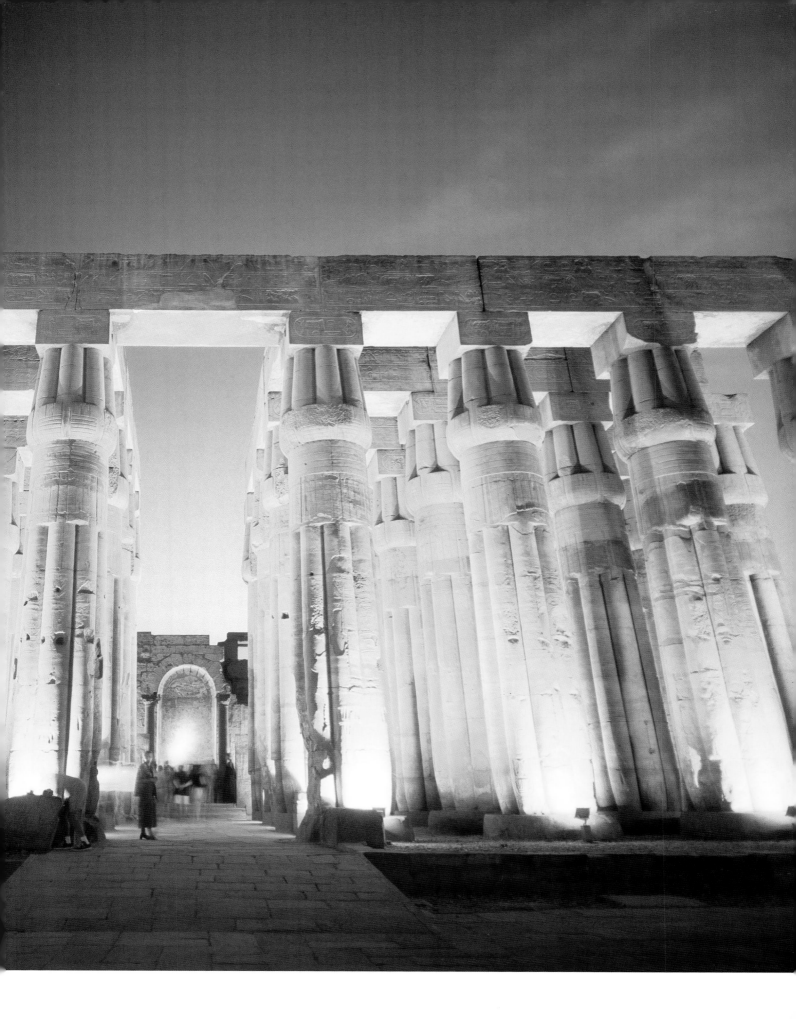

impossible [metering situations]

Sometimes there are photographic circumstances that no meter can read. These don't happen often, but you should be aware that they do occur. All is not lost, however, when you are confronted with one of these impossible-to-meter situations. First, the information in this chapter can help you. If you know the typical exposure for lightning, for example, simply use that data in the field, and you'll be fine. Second, you can learn from experience and keep notes. Next time you encounter the same photographic challenge, you'll be better equipped to assess the light. And third, you should learn the sunny f/16 rule. It will come in handy more than you would think.

the sunny f/16 rule:

There are three variables in exposure: shutter speed, lens aperture and film speed.

You can learn to read light without a meter more easily if you eliminate two of these variables and work with only one. Calculate exposure using the same shutter speed and the same film speed. Only the aperture varies.

The sunny f/16 rule states that at f/16, on a bright sunny day with the sun at your back, the correct shutter speed is the reciprocal of the ISO. If we use 64 ISO (like the old Kodachrome slide film) to illustrate this, the reciprocal of 64 is 1/64. The exposure then would be f/16 at 1/64, or in practicality f/16 at 1/60. Because 1/60 of a second is not a good speed for hand-holding a camera, I always use 1/125 at f/11 (which gives you the same amount of light reaching the film as 1/60 at f/16). See the appendix for more background on the sunny f/16 rule and for compensation guidelines under conditions other than sunny front lighting—shady conditions, backlit subjects or with the sun on the horizon.

Light meters cannot read black light accurately. The results are usually overexposure and a desaturation of the cobalt-blue color typical of black lights. Bracketing your shots is the only way to determine the correct exposure. Once you see the range of densities in the test roll, you can choose the one you like best.

This shot of a scorpion was a studio setup. The arachnid was dead, which allowed for the long exposure required for the depth of field I wanted. I did not use a filter.

tech data: Mamiya RZ 67 II, 250mm normal lens, 3 minutes, f/22, Fujichrome Provia 100F, tripod.

This snowflake was caught on a small sheet of glass as it fell from the sky. The glass was cold enough to prevent the fragile flake from melting. To make the shot, I placed the glass parallel to the ground with a flash mounted fifteen inches below this, off to one side, so that the flash itself could not be seen in the viewfinder. I used a piece of black fabric under the glass to achieve stark contrast. The only way I could deduce what the exposure should be was to use a Polaroid back on my Mamiya RZ 67. Without this, I could only bracket all over the place and hope to get one that worked.

tech data: Mamiya RZ 67 II, 110mm normal lens, four extension tubes, 1/125, f/32, Fujichrome Velvia, tripod.

The instantaneous burst of blindingly bright light set against a dark sky is more than any meter can handle. I use the following guidelines, which I've developed over the course of many years shooting lightning storms. These numbers are based on Fujichrome Velvia used at night. I simply open my shutter and wait for the strikes. If the bolts are very close, virtually on top of my head, I use f/11. If they are fairly close I use f/8, and if the bolts are at a considerable distance, I use f/5.6.

tech data: Mamiya RZ 67 II, 250mm telephoto, shutter open until lightning flashed, f/5.6, Fujichrome Velvia, tripod.

There is a chance that a TTL would have read this scene correctly, but I wouldn't bet money on it. There was no place in the glowing sky to take a reading, and the elephants were moving too quickly to take the time to read the middle tones in the ground with a spot meter. Incident meters don't work with backlighting. I was working against time here, so I simply used the sunny f/16 rule and manually set the shutter speed and aperture. This picture is proof that knowledge of this rule can save a great photo opportunity.

tech data: Mamiya RZ 67 II, 500mm APO telephoto, 1/250, f/6, Fujichrome Provia 100, camera rested on beanbag in Land Rover.

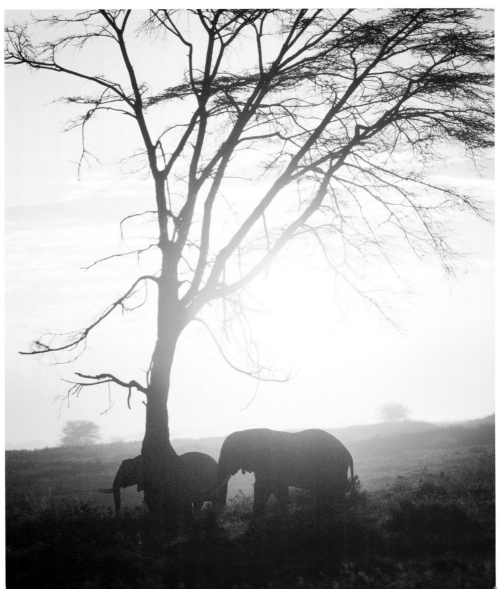

Another subject that eludes light meters is fireworks. Both incident and reflected meters wouldn't know what to do with the extreme contrast and the ever-changing shape of the fire. I photographed this young boy many years ago on Santa Monica beach in California during the 4th of July celebration, and I simply guessed at the exposure. In night photography, the latitude regarding acceptable exposures is much more than shooting in daylight. For example, this same shot may have worked if it were one f/stop underexposed or one f/stop overexposed—a two-f/stop latitude.

tech data: Canon EOS 1, 50–200mm zoom, approx. 2 seconds, f/8, Ektachrome 64, tripod.

Taken from a boat, this shot's brilliant reflection on the water contrasted with the black cliff faces in Glacier Bay National Park in Alaska. The kittiwakes punctuated the dark background, and the entire composition offered no middle gray from which a reflected meter could take a reading. Since the birds and the water were lit from behind, an incident meter was useless. Using the sunny f/16 rule as a guide, I basically guessed at this exposure.

tech data: Mamiya RZ 67 II, 500mm APO telephoto, 1/400, f/6, Fujichrome Provia 100, handheld.

This orca I photographed from a boat in the Johnston Straits in Alaska presented the identical problem I faced when shooting the kittiwakes: harsh contrast, backlighting, and no middle tones. I took an educated guess, also using the sunny f/16 rule as a guide.

tech data: Mamiya RZ 67 II, 500mm APO telephoto, 1/250, f/6, Fujichrome Provia 100, handheld.

I have used a TTL meter to shoot silhouettes against the sun, but it's impossible to know how much foreground detail you'll get in the final image. If the sun is brilliant and fills a large part of the frame, the meter will indicate a smaller aperture or faster shutter speed, which further darkens the foreground. If you use a wide-angle lens, reducing the sun to a small element in the composition, it will have less impact on the meter reading. Unless you bracket, allowing a choice in the editing process, you can't really be sure how the silhouetted parts of the picture will look.

I used the sunny f/16 rule as a guide to determine the exposure in this shot of Bagan, Myanmar. Had I reduced the exposure, the sun would have been more defined, but I would have lost all foreground detail and eliminated the depth in the picture. After arriving at my exposure, I compensated for the filter.

tech data: Mamiya RZ 67 II, 350mm APO telephoto, 1/4, f/32, Fujichrome Velvia, Cokin sunset filter, tripod.

For this night shot of the dancing fountains in front of the Bellagio hotel in Las Vegas, I used my standard exposure: eight seconds at f/5.6. Could I have metered on the hotel facade? Yes, but it really didn't appear to be middle gray to my eye, and I knew that an eight-second exposure would work. Remember that night photography is very forgiving, even if you over- or underexpose by a full f/stop.

tech data: Mamiya RZ 67 II, 50mm wide-angle lens, 8 seconds, f/5.6, Fujichrome Velvia, tripod.

The Sunny f/16 Rule

The sunny f/16 rule states that at f/16, on a bright, sunny day with the sun at your back, the correct shutter speed is the reciprocal of the ISO. In chapter nine we found one possible setting under these conditions with 64 ISO: 1/64 (or roughly 1/60) at f/16. This translates to 1/125 at f/11, a better setting for a handheld camera.

I mentally calculate exposure using 1/125 as my shutter speed and 64 as my film speed. Those never change. Only the aperture varies with the light. After I have made my mental determination of the exposure, I then adjust for Fuji Velvia or Provia 100 or for a different shutter speed/lens aperture combination. For example, on that same bright, sunny day, Velvia is 1/125 at f/8 plus 1/3 while Provia 100 is 1/125 at f/11 plus 2/3. The chart on page 143 will help you convert to other f/stops based on the shutter speed and ISO you desire.

Calculating Exposure for Other Conditions

With 64 ISO film and a shutter speed of 1/125, the correct aperture under various conditions is as follows:

- bright sun, front lit — f/11
- cloudy, bright, faint shadows — f/8
- open shade — f/5.6
- sun just above horizon — f/5.6
- sun on horizon — f/4

If you can remember these five exposure settings, you will be on your way to reading light without a meter. For other situations, take an educated guess, then check yourself. Over the course of a week, you should become very accurate. I did this many years ago with an incident meter to check my educated guesses, and I was surprised at how good my ability to read light became.

Sunny f/16 Rule & Backlighting

The sunny f/16 rule applies to front lighting and shaded conditions, but not to backlighting. I have, however, listed on pages 141–143 some situations that I frequently encounter along with the f/stop that gives me the best exposure. These numbers are based on the 40 ISO rating of Fujichrome Velvia.

Keep in mind that these are only guidelines that I use and that each situation can vary with respect to the type of subject, atmospheric conditions, and the position of the camera and subject with respect to the sun.

[quick reference chart]

conditions	f/stop	shutter speed	ISO
• bright sun, front lit	f/11	1/125 sec.	64
• cloudy; bright, faint shadows	f/8	1/125 sec.	64
• open shade	f/5.6	1/125 sec.	64
• sun just above horizon	f/5.6	1/125 sec.	64
• sun on horizon	f/4	1/125 sec.	64

The sun is fairly high in the sky (3 P.M. to 4 P.M.) behind a subject where you want to expose for the shaded side of the subject: 1/125 at f/4.5.

[backlighting: exposing for the background in bright sun]

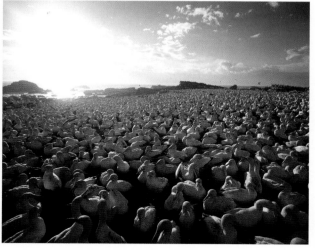

The sun is fairly high in the sky (3 P.M. to 4 P.M.) behind a subject where you want to expose for the background: 1/125 at f/8.

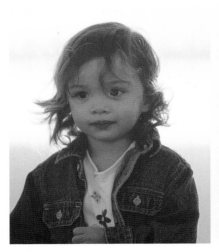
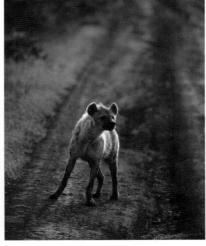

The sun is 5 or 10 degrees above the horizon (sunrise or sunset) and not seriously diminished by atmospheric haze, dust or smog, where you want to balance the exposure between the shaded side of the subject and the background: 1/125 at f/4.

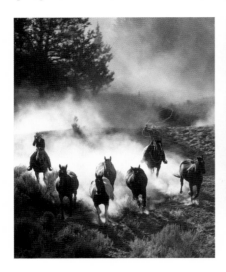
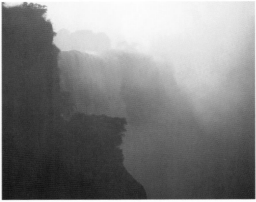

The sun is 5 or 10 degrees above the horizon (sunrise or sunset), and your subject is translucent, such as mist or dust: 1/125 at f/5.6 plus 1/2.

The sun is close to the horizon (sunrise or sunset), and you want to silhouette an opaque subject (like a tree) against the sky: 1/125 at f/5.6.